IMAGES
of America

CHESAPEAKE BAY
BRIDGE

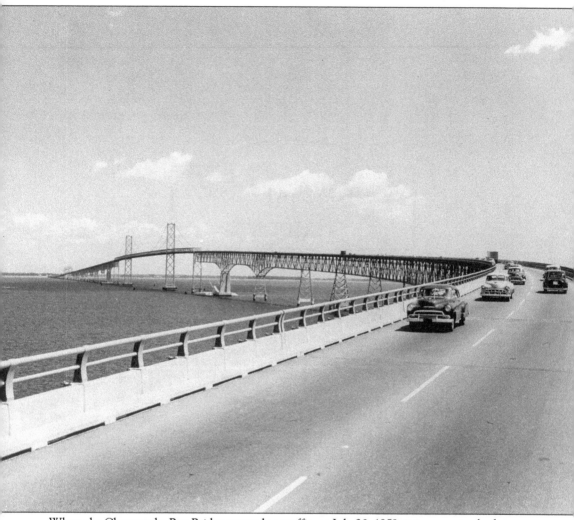

When the Chesapeake Bay Bridge opened to traffic on July 30, 1952, it was a watershed moment in the history of Maryland and the culmination of 40-plus years of its citizens longing for a better way to cross the bay. The span forever changed the state by linking two worlds that were long divided by a great body of water. Motorists, like those in this photograph speeding over the new structure from the Eastern Shore, had never reached the other side of the bay with such ease. Instantly, the Bay Bridge became an architectural landmark of the East Coast, and in the ensuing years, millions drove across its towering expanse of concrete and steel. (Courtesy of the Enoch Pratt Library.)

ON THE COVER: At the time of its completion, the Chesapeake Bay Bridge was the world's largest continuous over-water steel structure. Its construction was a colossal engineering feat, and the bridge was hailed as the realization of a distinctly Maryland dream. This photograph, taken in 1952, captured the change that had come to the state—as the towering new span stretches to the horizon, pulling Maryland into the future, watermen in the foreground harvest oysters with hand tongs, a technique passed down through the generations. (Courtesy of Aubrey Bodine.)

IMAGES
of America

CHESAPEAKE BAY
BRIDGE

John R. Paulson with Erin E. Paulson

ARCADIA
PUBLISHING

Copyright © 2019 by John R. Paulson
ISBN 978-1-5402-3873-3

Published by Arcadia Publishing
Charleston, South Carolina

Library of Congress Control Number: 2018964539

For all general information, please contact Arcadia Publishing:
Telephone 843-853-2070
Fax 843-853-0044
E-mail sales@arcadiapublishing.com
For customer service and orders:
Toll-Free 1-888-313-2665

Visit us on the Internet at www.arcadiapublishing.com

CONTENTS

ACKNOWLEDGMENTS

Erin Paulson, my writing collaborator, made numerous and valuable contributions to the text. Her crisp style and warm tone simultaneously sharpened and leavened many of its passages, and her editing streamlined the text.

Pete Lesher, curator and historian at the Chesapeake Bay Maritime Museum in St. Michaels, Maryland, provided insight into the cultural history of Maryland in the first half of the 20th century and the Bay Bridge's impact on the region. His often-wry perspectives added spice to the flavor of this book. He also proofread the text with an eye for its historical accuracy.

Dan Williams, chief engineer at the Maryland Transportation Authority, made understandable to me the field of civil engineering and the specialized construction processes that were used to build both spans of the bridge and kindly reviewed portions of the text for accuracy.

The Maryland Transportation Authority made available their extensive archive of photographs to make this book possible. Unless otherwise noted, all images in this book are from the collections of the Maryland Transportation Authority.

Maryland Public Television aired the program, *Spanning the Bay: The Chesapeake Bay Bridge*, the precursor to this book; as such I'm indebted to Michael English, whose sound judgment guided the story lines of the documentary, and thus this book. Patrick Ridgely performed extensive photograph research and unearthed many of the photographs seen in these pages.

With his editor's eye and a sharp pencil, longtime friend James Arntz made many sound and gentle suggestions that helped to clarify passages throughout the book.

I wish to express my deepest gratitude to Dawn, Sean, and Erin for their absolute and certain love and support.

INTRODUCTION

In 2011, I produced a television documentary that told the story of how the William Preston Lane Jr. Memorial Bridge—what many simply call the Bay Bridge—was built. I remember feeling impressed by the intricate details of the immense structure and of the high-flying construction processes that brought it into existence. Upon completion of the film, I wished to more permanently affix its story and the marvelous photographs we discovered into the pages of a book. I wanted readers to be able to gaze at images from the 20th century and marvel, as I had, at how workers built a four-mile-long roadway across America's largest estuary.

The story of a bridge is more than its concrete, steel, and asphalt components. It is the story of a crossing of barriers and of the linking up and tying together of people separated by those barriers. In the Mid-Atlantic region, the greatest obstacle to overcome is the Chesapeake Bay, a wide expanse of water that, in Maryland alone, runs 130 miles long and varies in width from 3 to 12 miles. The Chesapeake Bay splits most of Maryland into the Western and Eastern Shores, and until the building of the bridge, it was a formidable impediment that could only be crossed using some means of water transportation. For three centuries, Marylanders communicated with each other largely by boat.

The dream of a bay crossing began in the early 1900s with the efforts of Baltimore businessmen who worried that the lucrative products of the Eastern Shore would be lost to the more easily accessed cities of Wilmington and Philadelphia. Getting goods across the bay to markets in Baltimore and Washington, DC, was arduous; it was much more economical to transport them via the railroad tracks and automobile roadways that ran up and down the spine of the Delmarva Peninsula. Over the next 40 years, the bridge idea had numerous fits and starts. In the 1930s, the State of Maryland ordered studies to determine the best sites to locate a crossing and, in 1937, authorized the construction of a bridge to be financed by revenue from tolls. That was the plan until World War II came along and sank such hopes.

In the late 1940s, the bridge project regained its prewar momentum. Increasingly, motorists and truckers demanded that the state provide a way to cross the bay, and the politicians and financiers, led by Maryland's governor, finally responded with sound construction and financing plans. Everyone seemed to agree. In 1949, imbued with a deep sense of civic purpose, an army of engineers, surveyors, tugboat captains, underwater divers, riveters, crane operators, welders, concrete workers, and high steel men began to build what is now regarded as the penultimate architectural landmark of the Maryland landscape.

The bridge rose over the waters of the Chesapeake Bay in a dramatic 2.5-year period of progress. It was an ambitious job that became known to the workers as "Operation Link," because it would become the first physical link binding the two long-separated parts of Maryland. One of the construction crew chiefs was Elmer White, an old bridge hand who in his long career had already put up 39 bridges. In erecting this, his 40th and largest bridge, White exuded the American can-do spirit when he said, "I love bridge building. I hope I never have to do anything else. It is a pleasing thing to see a big bridge take shape and stand out against the sky above the water. This bridge is going to be a real beauty and I am going to watch it grow day by day."

All bridge building begins with the following question: how to traverse an obstacle? Erecting this span involved unique engineering variables. Even though it was planned for the narrowest section of the bay, it was an unusually long stretch of water to cross. The design had to hold up against relentless pounding traffic and the sometimes harsh forces of nature. Foundations had to be sunk into the bay's bottom, which consists of soft mud. Massive steel sections needed to be installed up to five stories high above water and braced so as to avoid the kind of catastrophic failure that had happened only recently in Washington State, when the Tacoma Narrows suspension bridge began to sway in strong winds until finally, undulating violently, the roadway fractured and tumbled into the valley.

And then there were choices to be made about the type of bridge to employ—whether a beam bridge, arched bridge, truss bridge, suspension bridge, cantilever bridge, or cable-stayed bridge. This begat rounds of decision-making, engineering know-how, creativity, and the emergence of a refined design aesthetic. It was decided that the Chesapeake Bay Bridge would consist of several different kinds of bridges strung together in series with a towering suspension section at the center—tall enough to allow the largest ships in the world to safely pass below it.

It seems to me the designers of the Bay Bridge, the cadre of civil, mechanical, geotechnical, structural, and design engineers, might have had in mind the Roman military engineer and architect, Vitruvius Pollio. In his treatise, On Architecture, written in the 1st century AD, Vitruvius set down the most basic principles of architecture when he declared that a good building should stand up robustly and last (fermatas); it should be suitable for the purposes for which it is used (utilitas); and it should be aesthetically pleasing (venustas). The engineers tactically designed the bridge to stand against the harsh beatings of wind, rain, snow, ice, and saltwater on the structure's metal skin and stone bones. Yet they also imbued their mammoth structure with imaginative form, so that it not only worked well and was safe to use, but was also pleasing to behold.

Engineer Elmer White echoed the centuries-old spirit of Vitruvius when he said, "What we are up against is this: the bridge designers saw the bridge in their imagination; they put it down on paper, precise to the tiniest fraction of an inch—like a guy writing a poem and getting the meter just right. It is up to us to make that poem come alive exactly as the designers saw it in their minds."

When construction began in 1949, one of the biggest fleets of marine construction equipment ever seen along the Atlantic coast was marshaled in to build "the physical visual symbol of reunification of the Free State of Maryland into a social, economic, and political unity," according to the Baltimore Sun. A journalist later wrote the following of those first months of construction and the feeling of promise that must have been in the air: "The ferries passed derrick after derrick, and the incessant thud of the pile driver interrupted the otherwise solemn spring air. The ferry riders in the waning days of that era were well aware that times were about to change." This book is a visual record of the change that occurred in 1952 when 60,000 tons of steel stretched from shore to shore across the Chesapeake Bay.

One

WHY A BRIDGE?

Fast-forwarding from the founding of the Maryland Colony to the years immediately before the construction of the Chesapeake Bay Bridge, Maryland's two disconnected shores had grown into discrete socioeconomic regions with contrasting identities and ways of life. The Western Shore had Baltimore, a colonial port city that grew into a manufacturing and shipping powerhouse and a locus of European immigration, while the rural and rustic Eastern Shore retained a bucolic lifestyle and was one of the more isolated regions in the entire Northeast. To travel from Baltimore onto the Delmarva Peninsula—so-named because it comprised most of Delaware, the Eastern Shore of Maryland, and the Eastern Shore of Virginia—meant driving north to Elkton, Maryland, around the northern tip of the Chesapeake Bay, and then back down the other side. The other option was aboard one of the many steamboats, and later automobile ferries, that plied the Chesapeake Bay. Either way, it was a long and onerous journey. In the first third of the 20th century, Marylanders, like the rest of the US citizenry, were becoming increasingly mobile, and nothing fueled that mobility like the advent of the automobile and the extensive road networks subsequently built for them. In the Chesapeake Bay region, residents of Baltimore and the more densely populated Western Shore were eager to get away to the wide-open spaces of the Eastern Shore, a place advertised as "the land of pleasant living," with charming small towns and resorts and abundant opportunities for hunting, fishing, sailing, and beach-going. By contrast, Eastern Shore residents liked the excitement and high-quality shopping of a visit to Baltimore, and farmers and watermen in the east, along with manufacturers in the west, were eager to sell to one another. Both sides shared the desire to deepen economic relationships and the bonds of statehood; however, the beautiful Chesapeake Bay was a problem.

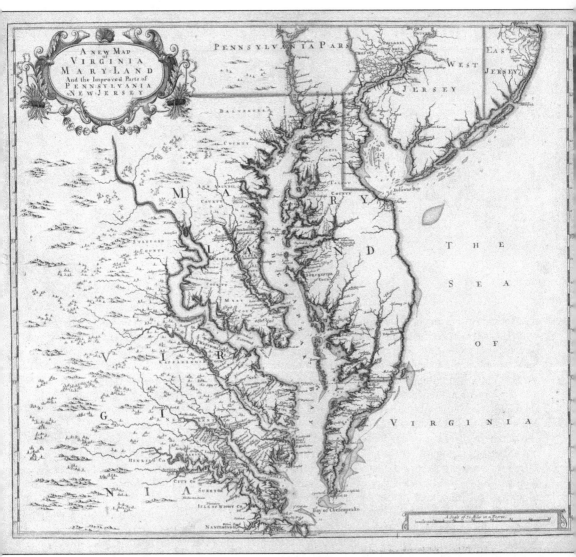

This c. 1700 map shows the Chesapeake Bay, the nation's largest estuary, and the separation of the Maryland Colony into two land masses. When the region was first settled by Europeans, they viewed the Chesapeake Bay as a vast maritime highway and chose to live right along its shores or tributaries. The bay provided a means of easy nautical communication. Sailing vessels of all types crisscrossed the bay, and such modes of transportation continued well into the 19th century and were the economic backbone of the growing state. But in the 1850s came the railroads, and then in the early 20th century, Henry Ford's Model Ts. With these new and swifter means of transit, the bay ceased to be a connecting link and instead became an obstacle, separating Maryland into essentially two islands. (Courtesy of the Library of Congress.)

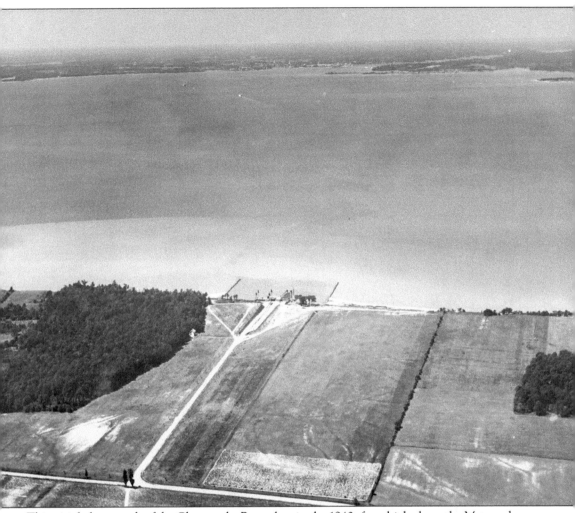

This aerial photograph of the Chesapeake Bay, taken in the 1940s from high above the Matapeake Ferry landing on Maryland's Eastern Shore, illustrates the physical gulf between the two sides of the state. It was near this spot that politicians would finally fund, and engineers would construct, the third-longest over-water span ever built. By 1900, commerce (agriculture and seafood products in the east and manufacturing in the west) and tourism (vacationers seeking resorts in the east) problems had become acute. Business leaders believed that it was high time the two sides joined hands across the bay. The earliest recorded mention of the practicality of a bridge was in 1907, in an address by Peter C. Sparks to the Baltimore, Maryland, Travelers and Merchants Association. The first serious proposal for a bay crossing came a year later, in 1908, when W.E. Weatherly approached the Baltimore, Maryland, Merchants and Manufacturers Association with a proposition to build a bridge. Over the next 40 years, several plans were proposed. (Courtesy of the Enoch Pratt Library.)

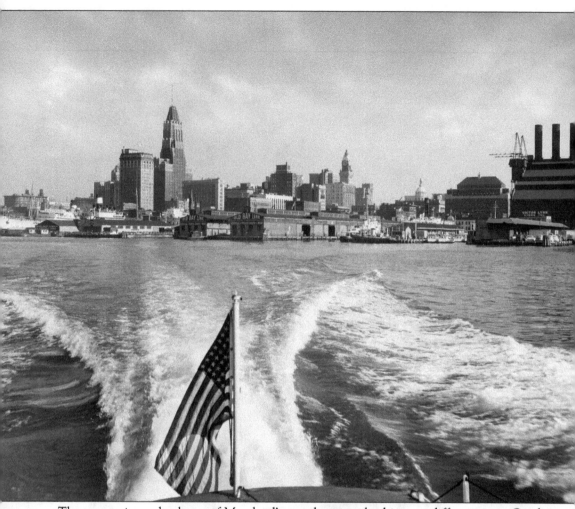

The economies and cultures of Maryland's two shores evolved in very different ways. On the Western Shore was the city of Baltimore, whose skyline is seen here from a motorboat leaving its harbor around 1942. Chartered by Maryland's colonial General Assembly in 1706 to ship tobacco, the city became an early American boomtown. Based first on a robust shipbuilding industry and then manufacturing, Baltimore doubled in size every 10 years between the Revolutionary War and 1810, becoming the third-largest city in the United States after New York and Philadelphia. Following the Civil War, the immigration pier at Locust Point—the second or third busiest in the country depending on the year—brought thousands of European immigrants to the city's factories, while the nation's first railroad, the Baltimore & Ohio, carried raw supplies and finished goods to and from distant markets. By the middle of the 20th century, Baltimore had grown into a powerful industrial force. (Courtesy of Aubrey Bodine.)

During the 19th century, Baltimore's manufacturing capabilities skyrocketed. Cotton mills, like the Hampden-Woodberry Mill, pictured, were among the city's most important economic centers. The mills were producing almost 80 percent of the world's cotton duck, the canvas cloth used to make ships' sails. Raw bales of cotton from the South were loaded onto ships bound for Baltimore, while finished goods sailed out from the city to various markets up and down the East Coast. (Courtesy of Aubrey Bodine.)

Baltimore attracted industry of all kinds. It was renowned as the straw hat capital, and the *Baltimore Sun* newspaper declared Baltimore the "center of umbrella trade" in 1922, when two million umbrellas were manufactured there. Fine men's suits, a Baltimore specialty, were tailored there and sold nationwide. Bethlehem Steel built the largest steel plant in the world at nearby Sparrows Point, and both General Motors and General Electric set up shop in Baltimore. (Courtesy of Aubrey Bodine.)

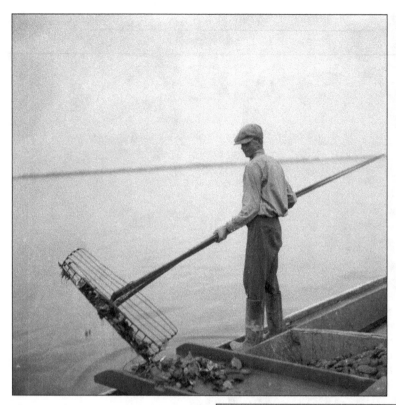

In contrast to the bustling Western Shore, the Eastern Shore had always been sparsely settled. It was a quieter, more rural place where farmers grew melons, sweet corn, and tomatoes, and watermen harvested rockfish, blue crabs and oysters. In this photograph, a waterman scrapes the bay's muddy bottom using traditional hand tongs and hauls up a catch of oysters. (Courtesy of the Library of Congress.)

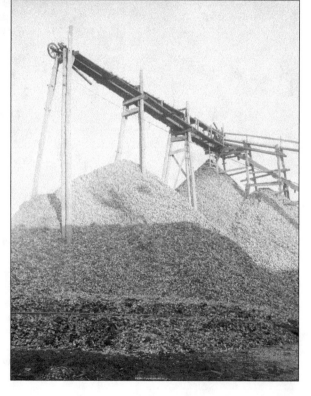

In the 19th century, and for much of the 20th, oysters were the great cash crop of the bay. Watermen made good livings harvesting oysters, and a thriving industry supported men and women who shucked them. These heaping piles of oystershells outside a shucking house stand as a testament to the immense supply of Chesapeake Bay oysters that were caught, canned, and shipped to all corners of the country. (Courtesy of the Library of Congress.)

The Eastern Shore's economy was also based on agriculture, but the most lucrative business for such produce awaited in the distant cities of Baltimore, Wilmington, and Philadelphia. For a long time, schooners, and later steamships, were the most economical connection to these urban markets. Here, the captain of this freight boat loads Eastern Shore melons into the hold of his ship. (Courtesy of the Library of Congress.)

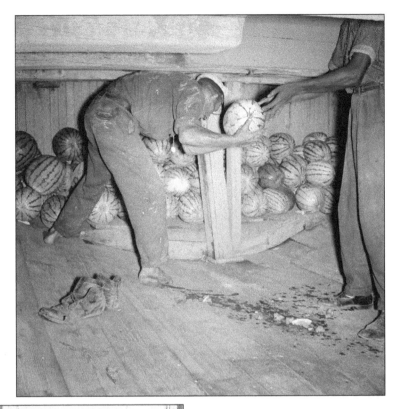

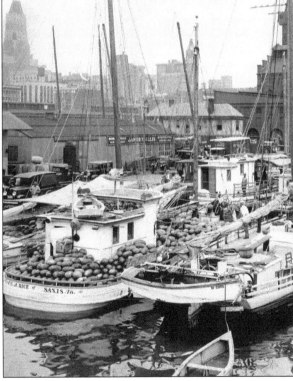

In this photograph from 1936, a Chesapeake freight boat, carrying a large deckload of melons, awaits unloading at the dock in downtown Baltimore. For centuries, such vessels sailed across the bay at a snail's pace, weighed down with the Eastern Shore produce and seafood. (Courtesy of Aubrey Bodine.)

15

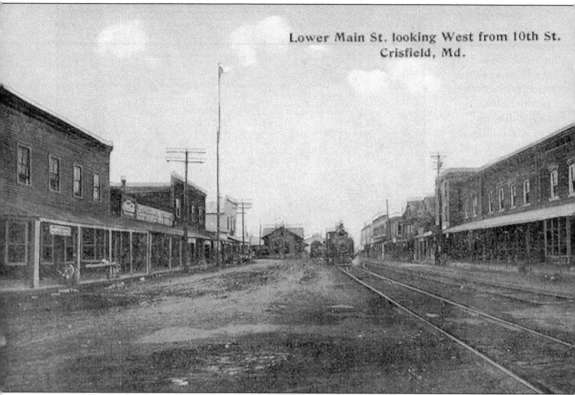

Lower Main St. looking West from 10th St. Crisfield, Md.

People of the Eastern Shore felt ever more separated from their fellow citizens in the west when, in the 1860s, railroad tracks were run southward along the spine of the Delmarva Peninsula all the way to the seafood processing town of Crisfield, Maryland. The new trains, such as this one seen on Crisfield's Main Street, traveled much faster and carried more volume than the old schooners, making it cheaper and easier to ship cargo up to Wilmington and Philadelphia than across to Baltimore. The loyalties of Eastern Shore business owners were tugged in opposite directions as they chose between sending goods to Baltimore via sail or steamships or northward to Wilmington and Philadelphia by rail. Increasingly, the more efficient railways won out, and the abundant seafood and agricultural crops of the lower Chesapeake Bay moved to hungry markets in the north at the expense of Baltimore in the west. (Chesapeake Bay Maritime Museum.)

Beginning with the first side-wheeler in 1813, appropriately christened the *Chesapeake*, steamships crisscrossed the bay providing a vital link between Baltimore and the rural towns to the east. The *Anne Arundel*, seen here, was one of many ships that steamed out of Baltimore with both passengers and freight. This photograph was taken in 1936 at St. Mary's City, Maryland, during the heyday of the steamship era. (Courtesy of Aubrey Bodine.)

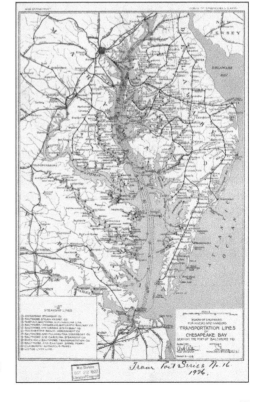

In 1926, the US War Department published this map showing transportation lines running up, down, and across the Chesapeake Bay. The inset lists 12 steamship lines active at that time. Steamboat service continued until automobile ferries, and later, the Bay Bridge became the faster and preferred way of crossing the bay. (Courtesy of the Library of Congress.)

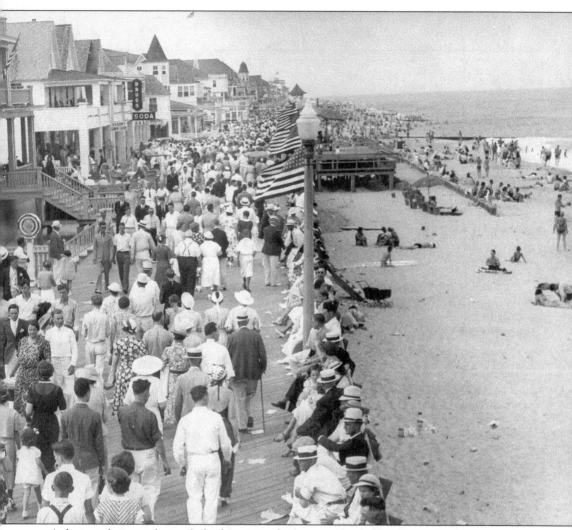

A decisive factor in favor of a bridge across the bay was the desire to increase tourism in Ocean City, Maryland, which had roots as a sleepy fishing village and then a hard-to-reach beach resort. The first beachfront cottage to receive paying guests was built in 1869, when people arrived by ferry and stagecoach. In 1933, the town was hit by a hurricane that flooded streets, destroyed the boardwalk, and knocked homes and hotels off their foundations, but it also cut a channel through the barrier island. Thus, the Ocean City inlet, a natural and safe harbor, was born, and the town's fate as a top-notch beach and sportfishing resort was sealed. Four years after the storm, the summertime crowds strolling the boardwalk, seen in this photograph taken in 1937, had swollen to record numbers. (Courtesy of the Enoch Pratt Library.)

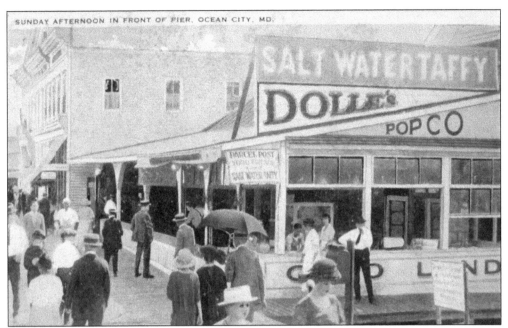

In 1910, Rudolph Dolle Sr. opened a small saltwater taffy stand in Ocean City on the corner of Wicomico Street and the Boardwalk. This postcard, thought to be from the 1930s, shows Dolle's famous Candyland open for business on a Sunday afternoon, selling homemade confections, taffy, caramel corn, and fudge to vacationers on the boardwalk, just a few yards from the Atlantic Ocean. (Courtesy of John Lynch.)

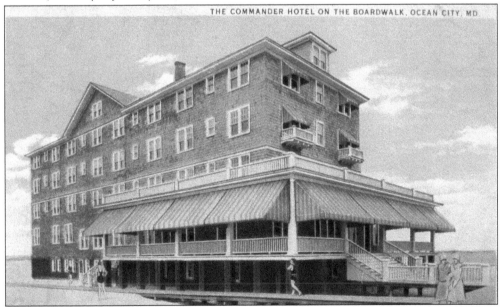

THE COMMANDER HOTEL ON THE BOARDWALK, OCEAN CITY, MD.

Elegant lodgings like the Commander Hotel, seen in this postcard shortly after its opening in 1930, sprang up to accommodate the incoming wave of vacationers from the west. While Ocean City became a prized destination and boon to Eastern Shore tourism, getting there from the other side of the state required an arduous trip, and all but the most intrepid travelers avoided it. (Courtesy of John Lynch.)

19

Prospects have brightened for bridging the Chesapeake, a project advocated intermittently for 40 years. The artists have sketched the proposed bridge from rough plans drafted in 1938, and placed it at the location generally favored. It would be four miles long and its 1,200-foot central span would be 175 feet above the bay.

Picture map by Sunpapers Artists Ockert and ?

Bay Bridge...New Hope For Old Dream

By FRANK HENRY

CONSTRUCTION of a Chesapeake Bay bridge, proposed 40 years ago as "a daring and Napoleonic scheme" to bind together the Eastern and Western shores, has been authorized for the third time by the State Legislature. Officials and engineers of the State Roads Commission, under whose supervision the great bridge would be built, believe that this time it will materialize and that by the early 1950's its huge main towers will rise from the bay.

Spanning the bay for nearly four miles, from Sandy Point to Kent Island, the bridge, projected for two lanes of traffic, would be one of the distinguished engineering works of the country. It would strengthen relations not only between Baltimore and the central and lower counties of the Shore, but would form part of a new tourist route along the Atlantic Coast, one which would divert much traffic from the ferry across the mouth of Chesapeake Bay.

Optimism over the newest bay bridge project is based mainly on two factors: the method of financing and the earnings prospects. The State Roads Commission has been given powers, somewhat like those of the Port of New York Authority, by which it can apply excess earnings of the Susquehanna and Potomac River toll bridges toward the financing and maintenance of the proposed bridge.

Half Of $6,000,000 Loan Paid

Earnings of the river bridges, since their opening in 1940, have far exceeded predictions of traffic engineers after surveys made in 1938. Already the Roads Commission has repaid $3,000,000 of the $6,000,000 loaned by the State for the first Susquehanna span. The other bridge, over the Susquehanna,

now using the Matapeake ferry (which the bridge would supplant), and the prospects for diverting some of the traffic from the Cape Charles-Little Creek ferry.

Incidentally, the volume of traffic on the Cape Charles-Little Creek ferry gives some idea of the potential business which may be attracted to the bridge. Reports for 1946 show that 230,902 automobiles, 94,370 trucks and 3,775 buses crossed by ferry in that year. However promising the Cape Charles traffic figures may seem for the bay bridge, experts realize that some of it is of a purely local nature. But they also know that a substantial percentage of it is through North-South travel which the bridge would expedite.

Traffic On Ferry Climbing

The two great centers of population to be served by the bay bridge are Baltimore and Washington. There, in the neighboring Maryland counties and on the lower and central Eastern Shore, live approximately 2,250,000 people. The bulk of the traffic handled by the Matapeake ferry comes of this population. In 1945 the ferry served 282,379 trucks and automobiles; last year the number had risen to 395,103. Indications are that ferry traffic for 1947 will far surpass the 1946 volume.

The experts reason that if the ferry handles such a volume of traffic while operating only eighteen hours a day and in spite of long waits between loads—lines of waiting cars extend back from the ferry terminals in summer—the volume of cross-bay travel would be greatly increased by the bridge.

of the voyage from Sandy Point to Matapeake. In addition there is the time consumed in going aboard the ferry and waiting for the "all aboard!" before she starts. And automobilists are fully aware of the long waits usual during vacation week ends—an hour, perhaps two hours when they miss a boat, or because of the long lines of cars ahead of them, which fill the boat to capacity (30 cars).

Would Mean Money To Farmers

Salisbury, 109 miles, could be reached by the bridge in 2 hours and 25 minutes; Easton, 62 miles, in 1 hour and 22 minutes; Pocomoke City, 137 miles, in about 3 hours, and Crisfield, 142 miles, in about 3 hours and 10 minutes. Via the ferry 25 minutes must be added to the running time in every case, plus the other delays mentioned.

An official of the State Roads Commission called attention the other day to one of the practical considerations which deters Eastern Shore farmers from bringing their produce to the Baltimore market.

"Say, for example," said the official, "a farmer has a 30-foot truck loaded with 100 watermelons and wants to bring them to Baltimore for sale. His ferry toll would be $4 each way—bringing them over and returning with his empty truck. That would mean a tax of 8 cents on each melon. In other words, he would have to figure $8 out of his profits before he had even sold the melons. Of course, if he could get more melons on his truck the cost per melon would be less. But he dare not pile them too high because the weight would crush

the time required to reach Philadelphia. And that, they believe, would bring many new shoppers to Baltimore stores.

Looking farther afield, students of traffic envision the bay bridge as important to traffic moving from New England and New York to Florida. For years tourists going south have used the main highway down the Eastern Shore to the Cape Charles ferry. They then proceeded down the coast to Florida resorts, avoiding large cities and their traffic. And the big trailer trucks bearing early produce from the South have customarily taken this route to northern markets.

It is felt that the bay bridge would offer a quick passage to the Western Shore, where good highways run down through Southern Maryland to the Potomac river bridge. Following that route they would avoid the hour-and-a-half ferry run across the lower bay.

Three are the prospects for traffic over the bay bridge as some of the experts see them. Mr. Codd is especially enthusiastic over the idea of using the profits of the Potomac and Susquehanna river bridges to aid in financing the bay bridge.

Sees Patapsco Span Brought Nearer

"It is an excellent idea," he said, "if carried to its logical conclusion it would realize for Maryland many good things. For instance, the Potomac and Susquehanna bridges are to aid in begetting the bay bridge. Then, in turn, the bay bridge and the two river bridges could beget the Patapsco river crossing."

The bay bridge, according to current estimates, may cost about $25,000,000. It is

Talk of a Chesapeake Bay crossing dates back to the 1880s, and by the 1920s, as Baltimore merchants watched the fruits of the Eastern Shore head north to Philadelphia instead of them, the bridge issue had come to a boil. In 1927, local businesspeople were authorized to build a bridge from Baltimore to Tolchester Beach, but they would have to finance it themselves. Plans were even drawn up, but hopes were dashed with the stock market crash of 1929. Federal authority for the construction of the bridge was given Congressional approval on April 7, 1938, but that effort was postponed by World War II. When the war ended, Maryland turned its attention to improving its statewide network of roads and bridges, and as part of that transportation infrastructure development initiative, the state legislature in 1947 revived the plan. The bridge, which had been derided in the *Baltimore Sun* as "a daring and Napoleonic scheme," was authorized for the third time, and Maryland had new hopes for an old dream. (Courtesy of the *Baltimore Sun*.)

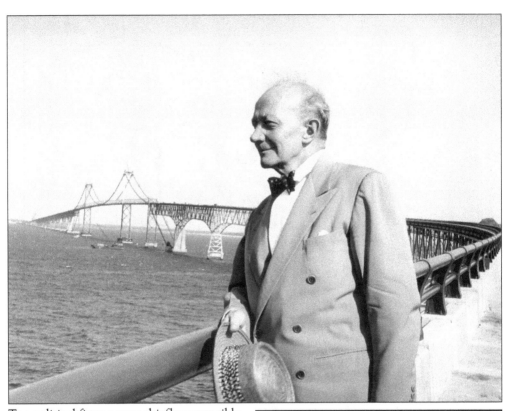

Two political figures were chiefly responsible for the bridge: William Preston Lane Jr. (above), who served as governor from 1947 to 1950, and Theodore R. McKeldin (right), his successor. Lane made construction of a Bay Bridge a campaign promise, and once elected, one of his top priorities. Under his leadership, the General Assembly approved and set into motion the largest public works project in Maryland's history. In August 1949, despite detractors who reviled the proposal as "Lane's folly," Governor Lane ordered work to begin on the mammoth over-water structure, estimated to cost $41,000,000, according to the *Baltimore Sun* on August 16, 1949. It would be financed by state-issued bonds to be repaid not by the taxpayer, but by tolls. After taking office in 1951, Theodore McKeldin also championed the bridge and enthusiastically managed the project through to completion. Both governors celebrated their achievement several years later at the bridge dedication, where they shook hands, grinned broadly, and took turns cutting the ribbon. (Both, courtesy of the Maryland State Archives.)

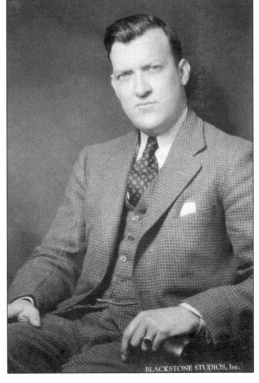

BLACKSTONE STUDIOS, Inc.

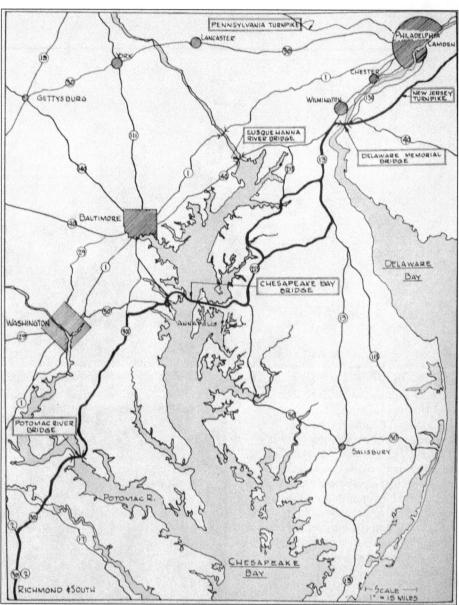

By the mid-1940s, there was general agreement that the graceful steel structure, more than four miles long, should span the bay at its narrowest east-west point, from somewhere in the vicinity of Annapolis over to Kent Island, as shown on this map. In 1947, the State Roads Commission took the first step in the construction process and awarded a contract for location studies to determine precisely where the bridge should be built. The contract went to the J.E. Greiner Company, the most prominent civil engineering firm in Maryland, under the supervision of its senior partner, Herschel Heathcoat Allen, one of the nation's most prolific bridge designers. As part of its foundation studies, Greiner employees bored deep into the soft bottom of the bay to determine whether the ground below the bay was capable of bearing the enormous load of the bridge. These subsurface explorations were completed in June 1948, and the bridge's route was established. In 1949, Maryland's citizens and teams of construction workers alike were eager for ground to be broken. (Courtesy of the Maryland Transportation Authority.)

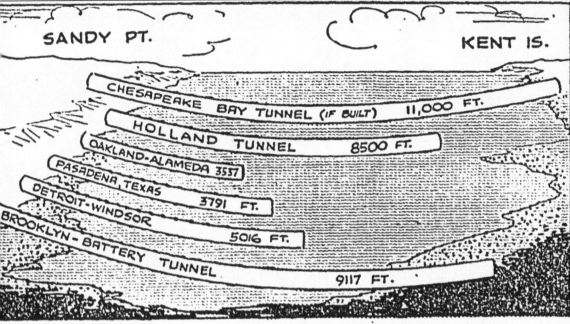

SANDY PT. KENT IS.

CHESAPEAKE BAY TUNNEL (IF BUILT) 11,000 FT.

HOLLAND TUNNEL 8500 FT.

OAKLAND-ALAMEDA 3557

PASADENA, TEXAS 3791 FT.

DETROIT-WINDSOR 5016 FT.

BROOKLYN-BATTERY TUNNEL 9117 FT.

A Chesapeake Bay tunnel would be the longest, under water, in the world.

Even though the bay crossing had always been referred to as a bridge, there had been no definitive decision as to whether it would be one continuous span, a pair of bridges extending out from each shore with a tunnel in the middle under the main shipping channel, or a complete shore-to-shore tunnel. The Maryland State Roads Commission hired the engineering firm of Palmer & Baker and asked them to explore the construction of a tunnel along the bridge line and issue a report of the engineering features, construction cost estimates, and projections of maintenance and operation costs of such a bay-crossing tube. They proposed a tunnel that, if built, would be the longest of its kind in the world, running 11,000 feet portal to portal. Ultimately, the type of crossing selected was one which cost the least to construct, and the tunnel proposal, illustrated here, was voted down by both the governor and the Maryland State Roads Commission. (Courtesy of the *Baltimore Sun*.)

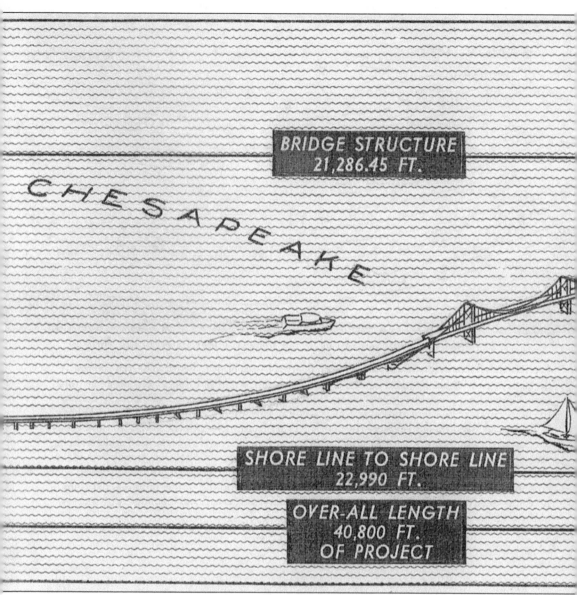

BRIDGE STRUCTURE
21,286.45 FT.

CHESAPEAKE

SHORE LINE TO SHORE LINE
22,990 FT.

OVER-ALL LENGTH
40,800 FT.
OF PROJECT

Where the bridge crossed the bay, one point was indisputable—it could not interfere with the shipping channel that brought cargo to and from the Port of Baltimore. That made locating the bridge a delicate issue. The state wanted to use the existing road leading to the Sandy Point ferry as the new bridge's feeder road, but under that plan, the bridge would have crossed the bay's commercial shipping channel at an angle—a maritime engineering infraction that would have killed the project. The US Army Corps of Engineers, the ultimate authority on the project, required that the bridge cross the shipping channel at a 90-degree angle. It was a fixed mandate that bridge designers had no choice but to work with, and the solution was the graceful curve for which the bridge is now famous. As the construction project became more certain in 1949, voices both for and against the bridge came out of the woodwork. Naysayers claimed the bridge

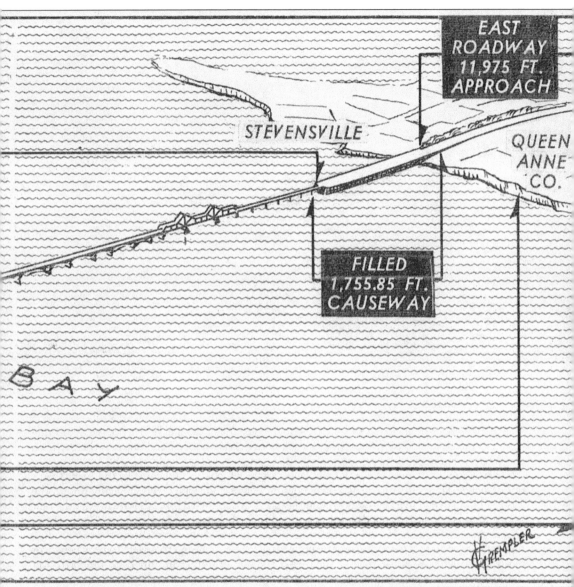

EAST
ROADWAY
11,975 FT.
APPROACH

STEVENSVILLE

QUEEN
ANNE
CO.

FILLED
1,755.85 FT.
CAUSEWAY

BAY

would topple with the first ice floes of winter; others worried that a passing freighter might crash into a pier at night. One concerned Baltimorean, Robert E. Thomas, perhaps with the memory of World War II in mind, wrote to the *Baltimore Sun* that a bridge would be more susceptible than a tunnel to enemy attack. He suggested that the span should somehow be bomb-proofed, noting that "one hit could easily eliminate" it. He further thought a tunnel would be a place of refuge and cited the London Underground subway system as a successful example of a tunnel that sheltered citizens from falling bombs. Brusquely dismissing Thomas, the newspaper editor said, "The Army engineers can be considered competent to judge the military aspects of the Bay Bridge." (Courtesy of the Maryland Transportation Authority.)

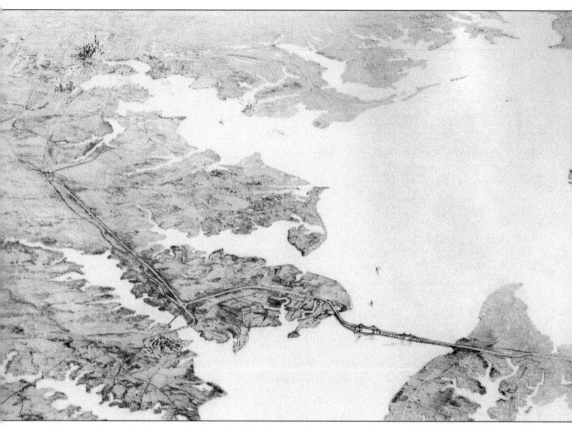

This artist's rendering appeared in the J.E. Greiner Company's Chesapeake Bay Bridge engineering report, completed in 1948. It shows a proposed bridge that would extend out into the bay from the Western Shore near the city of Annapolis. Then, it would gradually rise and curve so as to cross the shipping channel at the perpendicular angle, which was mandated by the Army Corps of Engineers. There, it would reach its maximum height and slope down gradually toward the Eastern Shore to end in a causeway on Kent Island. Transportation officials foresaw that the new bridge would be a huge draw to travelers from both the Baltimore, Maryland, and Washington, DC, metropolitan areas. Therefore, the bridge project included improvements to the surrounding highways. Seen in this rendering are the network of feeder highways that were to be widened, or newly constructed, to accommodate the higher volumes of traffic running back and forth over the span after its completion. (Courtesy of the J.E. Greiner Corporation.)

Two

BUILDING BEGINS

On the frigid morning of January 12, 1949, a large crowd had gathered at Sandy Point, Maryland, on the shores of Chesapeake Bay, to witness the ground-breaking ceremony for the Chesapeake Bay Bridge. Accounts of the day mention that, because Marylanders had waited so long for a bridge span, many of them came with as much disbelief as anticipation. As the *Baltimore Sun* newspaper reported, "Many who attended the official ceremonies at Sandy Point today will have to rub their eyes and look again. For it will be difficult for them to believe that construction of the Chesapeake Bay Bridge is actually begun." An inch and a half of snow fell, but spirits were high. It had been more than 40 years since the first serious proposal for a bridge, and during that time, plans to overcome the barrier of the bay had been the subject of almost unending discussion and speculation. Along the way, the idea had acquired both staunch supporters and vociferous opponents. But on January 12, as the first ground was bulldozed for the western approach, there was no doubt that Maryland was going to get its long-anticipated cross-bay bridge. Establishing a foothold was the first major task. Surveying crews marked the bridge's path through the water and the location of the 57 piers that would support it. Engineers determined that the soft layers of silt below the Chesapeake Bay would not be reliable, so some 80,000 cubic yards of mud were pumped up from the bottom, and pier holes 20 feet deep in places were filled with a bed of stable sand. After much dredging, work commenced on driving the piles, sinking the pier forms, and pouring tons of concrete into the forms. By far, the biggest underwater challenges were building the foundations for the two monumental suspension towers and constructing the hulking piers, which anchored the suspension cables. As winter's grip gave way to spring's thaw, work ramped up on these underwater supports.

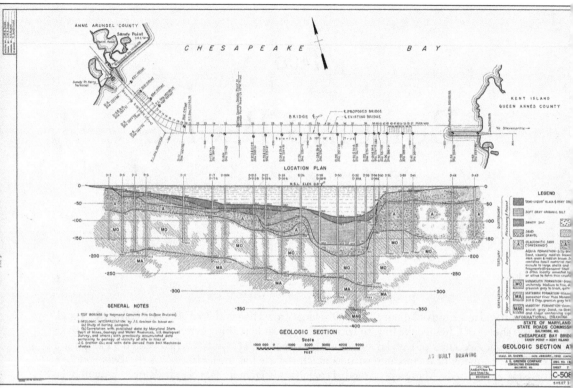

In preparation for what one newspaper called a "super colossal production," subsurface explorations of the bay's geology, consisting of soundings and borings, were made to determine foundation requirements for the bridge. In 1947 and 1948, test borings were taken at locations along the proposed line of the bridge, as seen in the above cross-section view of the bay. The deepest holes were drilled 354 feet from mean low water through layers of silt, sand, gravel, and clay. The resulting samples revealed a soft bed of mud underlying the bay that needed to be excavated to reach substrata dense enough for the placing of foundations. In late 1949, one of the biggest dredge boats in the world was brought in for the job, a 1,000-ton dredger nicknamed the "Big Dipper." The Dipper, operated by a crew of 40 who kept it operating around the clock, scooped up 15 to 20 tons of muck with every bite of its 20-ton snout to dig holes for the steel and concrete piles that anchored the bridge's central suspension span. (Courtesy of the Maryland Transportation Authority.)

28

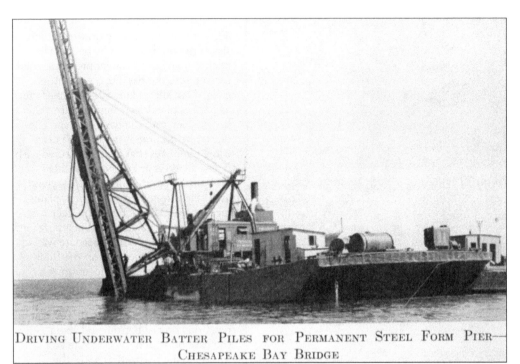

DRIVING UNDERWATER BATTER PILES FOR PERMANENT STEEL FORM PIER—
CHESAPEAKE BAY BRIDGE

The Chesapeake Bay Bridge is like an iceberg—more than half of it resides underwater. To get the subaquatic foundations started, the largest flotilla of marine construction equipment ever assembled on the East Coast was strung across the bay. After the bay's bottom was prepared by dredging operations, pile drivers atop barges lined up along the bridge's path (above) and rammed six- to eight-ton steel piles, the height of a 12-story building, into the bottom of the Chesapeake. The deepest piles penetrated 203 feet below water level and were driven by 11.5-ton hammers, poised 13 stories above, on the bay's surface (below). A hammer operator knew that when it took 60 consecutive blows to sink a pile a distance of one foot, the driving was complete. Underwater steam pile-driving hammers were used for this work, which required bridge designers to develop special methods to accurately locate the piles. (Both, courtesy of the Maryland Transportation Authority.)

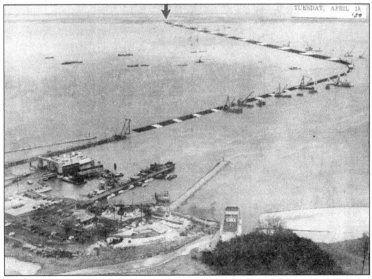

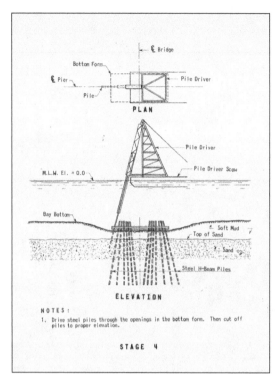

PLAN

ELEVATION

NOTES:
1. Drive steel piles through the openings in the bottom form. Then cut off piles to proper elevation.

STAGE 4

This bridge-engineering drawing at left shows the method used by builders to anchor many of the larger piers into solid earth under the bay. First, excavators gouged out silt and mud at each pier site, and then, pile drivers hammered steel H beams deep into the bay's bottom. The piles were accurately guided into place using templates that were punctured with holes. Workers at Pier No. 6, located on Pratt Street in Baltimore, Maryland, assembled these huge timber templates, measuring 80 feet long and 40 feet wide (below), that served as mapping grids for the piles. The procedure was to sink one of these mats on the floor of the bay at the precise location of a pier and then drive pilings through the preset holes. Finally, when all the steel piles were pounded into place, the mat remained on the bottom and acted as the base on which the concrete pier was poured. (Both, courtesy of the Maryland Transportation Authority.)

J. E. GREINER CO., CONS. ENGRS.
CHESAPEAKE BAY BRIDGE
CONTRACT NO. CBB-10-9-87, ALT. 2
PICTURE NO. 13
MATS, PIERS 24, 25, 26, 27.
MAR. 31 PROGRESS FOR MARCH 1950

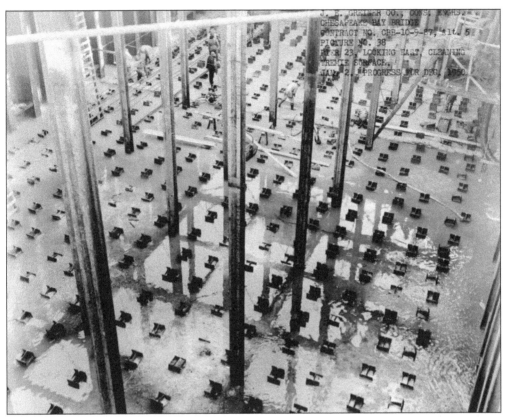

After all the steel H beams were permanently driven, divers armed with waterproof saws, nicknamed "underwater lumberjacks," built up walls around the perimeter of the giant wooden mats, thereby turning them into forms for concrete pouring. The photograph above shows the finished base of Pier No. 23 after all the H beams had been battered through the holes in the timber grid. Men can be seen preparing the site for the next step, which was concrete pouring. The bridge plans at right illustrate the process. Cylindrical steel sections were lowered onto the timber mats, and then concrete was pumped into them. One by one, sections of tubular steel forms were lowered into place and filled with cement, and the pier gradually grew from a sturdy base until it reached the surface of the water. In this way, especially out in the depths of the bay, piles could be driven and piers formed that were sturdy enough to hold up the colossal weight of the above-water portion of the structure. (Both, courtesy of the Maryland Transportation Authority.)

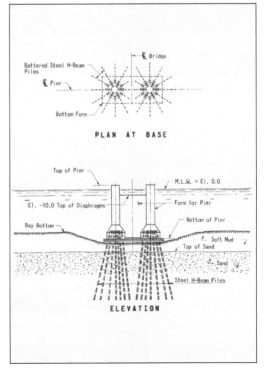

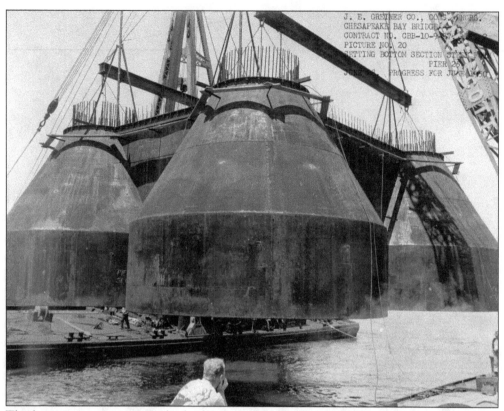

The largest piers supporting the bridge were those built for the suspension towers and the suspension cable anchors. The piers were constructed in the new "Potomac" style, which was specially designed by Herschel Allen of the J.E. Greiner Company and so-named because the type of pier had been perfected in an earlier bridge Greiner had built over the Potomac River. Herschel Allen's Potomac process allowed the construction of large bridge piers in deepwater depths, thereby eliminating the need for cofferdams, the costly watertight enclosures that are pumped dry to permit construction work below the waterline. In June 1950, the above four-sectioned bell-bottom iron can, an important cost-saving element of the Potomac pier design, descended to the bottom of the bay to be the form for Pier No. 25, the west suspension tower. Once submerged and in position on the bottom of the bay, the inverted funnels were pumped full of conventional concrete. After the pour, the steel molds remained in place and became a permanent part of the bridge. (Both, courtesy of the Maryland Transportation Authority.)

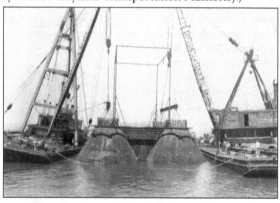

Born far from any major body of water in the hills of northeastern Baltimore County, Herschel Allen somehow cultivated a dream at the age of nine to design and build a bridge. And after becoming one of the first students to enroll in the Johns Hopkins engineering graduate school and, later, a bridge designer through the State Roads Commissions of Maryland, Allen was able to count himself among the lucky few to see their childhood dream come true. Allen designed the new deepwater Potomac piers that were used on the Chesapeake Bay Bridge and continue to be utilized today. Potomac-style piers were used for 28 of the Bay Bridge's 65 piers, saving builders the prohibitive expense of dredging away the layers of muck at the bay's bottom for cofferdams. Instead, the base of the piers rest on clusters of steel piles driven through the muddy bottom into the firm sands that underlie the bay. In this way, the bridge rests on solid ground. (Courtesy of George Jenkins.)

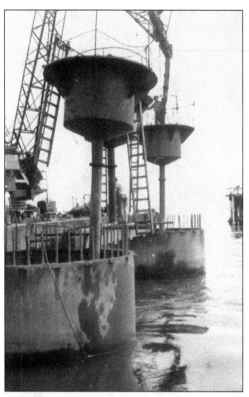

A special method known as "tremie," from the French word meaning "hopper," was required to pour concrete for the bridge's subaqueous footings. The method, being employed here at Pier No. 24, involves pouring concrete from the hopper into the vertical pipe running down into cylindrical forms. As the concrete discharges out the pipe, the chamber fills and the tremie pipe rises. (Courtesy of George Jenkins.)

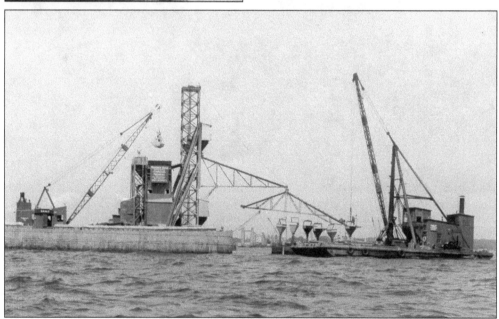

The tremie pipe was raised and lowered by a derrick or crane, as seen here. As newly mixed concrete flowed out of the pipe and into the chamber, the bay water in the chamber was displaced and gushed out of the top. The tremie pipe was continuously loaded with a fresh concrete mix so that the pour and displacement occurred uninterrupted. The tremie pipe proved to be an expeditious way to pour large volumes of concrete at great depths. (Courtesy of George Jenkins.)

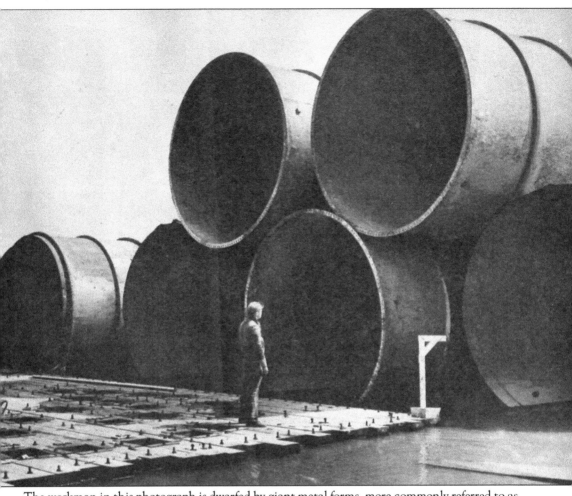

The workman in this photograph is dwarfed by giant metal forms, more commonly referred to as cans, more than 20 feet in diameter. The cans were the round enclosures into which immense amounts of concrete were poured using the tremie method to make bridge piers at the bottom of the bay. During the first six months of 1950, men worked around the clock in three shifts in order to speed up construction of these huge supporting piers. One after another, the cans were submerged into the water, where teams of construction divers joined them end to end. Each form was connected to the one below it, then pumped full of cement. In this way, concrete columns encased by the metal forms grew from the bay's bottom to a height that stopped just below the water surface. Like the bell-bottom cans of the Potomac pier, these metal tubes were then left in place in the water to eventually rust away. This had no effect from a structural standpoint; having served their purpose—to be a mold for the piers that hold up the bridge—they were no longer necessary. (Courtesy of Gene Melvin.)

35

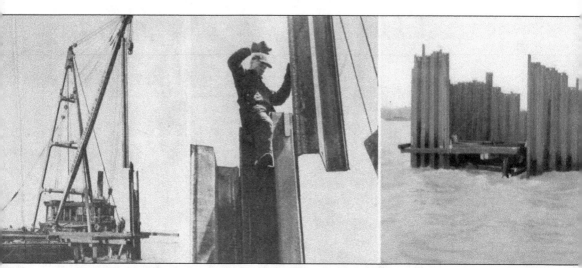

A few cofferdams were also necessary to build some of the bridge's larger footings. Creating a perimeter from interlocking steel sheets for these watertight islands, as seen here, was a risky job. One journalist wrote the following:

> Of all the tasks aboard the barge, none is more dangerous than that of the so-called "sheathing monkey"—the man who fits one sheet of piling into another. Like a human fly, he shimmies up the smooth face of the first piling after it is plunked into the slit and held in place by the derrick boom. Crouching on a pair of iron stirrups hung over the beam top, he fits the pilings together very much as if they were huge tongue-in-groove boards . . . It takes a man of steady nerves to sit there calmly while several tons of metal come crashing down a few inches from his nose and shiver the beam on which he's sitting.

Once it was pumped dry, the cofferdam allowed men to work inside it and to pour the concrete footings. (Both, courtesy of Gene Melvin.)

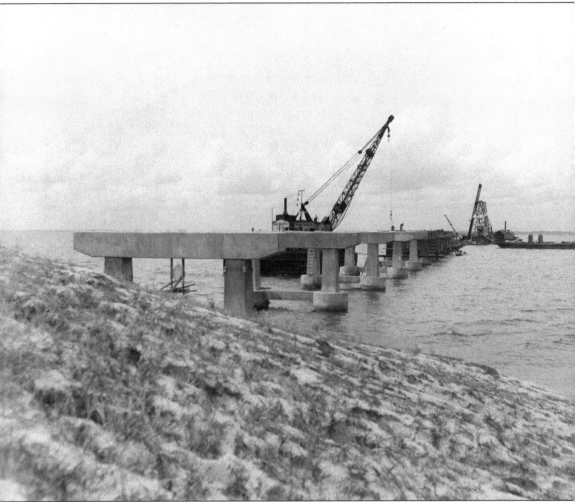

The immensity of the footings project is best illustrated by considering the materials going into a single pier. For example, Pier No. 23, which anchors the suspension span cables, had 600 piles driven for a total length of 41,200 lineal feet, just a little short of five miles. By October 1950, 11 months after ground had been broken on the project, some 2,000 bridge workers were engaged in underwater construction efforts on the new bridge. The Bay Bridge's foundation and substructure jobs cost some $18,000,000, nearly half of the $45,000,000 overall cost of the bridge. This photograph is of the pile bents being built out from the Anne Arundel County shore on the western side of the bay. A series of these trestle-like support structures were built to hold up the first 2,300-foot stretch of roadway that extended from firm land out over the water. Over on the opposite shore, a rock-ribbed causeway approach to the bridge was built out into the bay from Kent Island. (Courtesy of the Maryland Transportation Authority.)

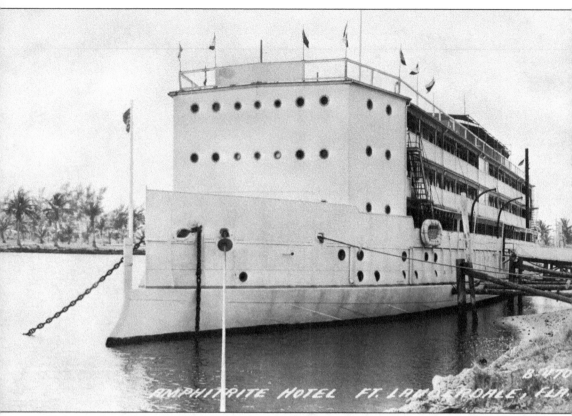

AMPHITRITE HOTEL FT. LAUDERDALE, FLA.

To house the influx of workers for the bridge, an old floating hotel, the *Amphitrite*, was hauled up the Chesapeake Bay in May 1950 and moored near the construction site at Sandy Point. The hotel ship provided accommodations for approximately 200 men, with two men to a stateroom. Each room opened out onto the deck and was equipped with steam heat, running water, a toilet, and a telephone. The *Amphitrite* was noteworthy for having been built by the US government after the Civil War for the defense of ports along the Atlantic Coast. However, it became obsolete rather quickly, fell into private hands, and was refashioned as a floating hotel. It is rumored that gangster Al Capone wanted to purchase it at one time and make it a casino. On the Chesapeake Bay, it was a convenient job site home for men who otherwise would have commuted from afar. (Courtesy of the Florida State Library and Archives.)

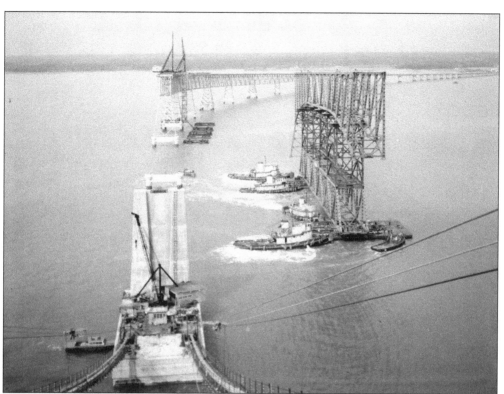

By December 1950, most of the substructure for the Chesapeake Bay Bridge was completed, and builders turned their attention to the erection of the steel superstructure. Bethlehem Steel Company had the contract for the superstructure and built dozens of steel truss sections like the one seen here. (Courtesy of the Hagley Museum.)

Many trusses were fabricated on floating derricks at the construction site, and it was a difficult operation that was subject to frequent interruptions by high winds and waves. Others were fabricated 16 miles up the bay at the Sparrows Point foundry of Bethlehem Steel and then barged down to the work site. Overall, more than 17,500 tons of steel went into the bridge's substructure, and 30,000 tons of steel went into the superstructure. (Courtesy of Aubrey Bodine.)

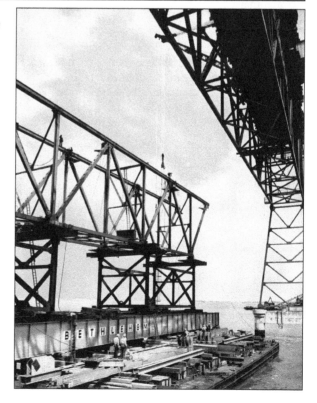

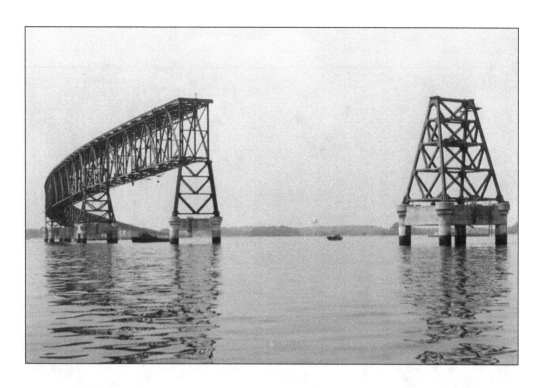

Engineering buffs are quick to point out that the design of the Chesapeake Bay Bridge is extraordinary. The soaring suspension towers immediately catch the eye, but the bridge is actually several different types of spans connected in series. At the western abutment, the bridge deck is first carried by a series of 30 beam spans, each 60 feet long. Following these from west to east, the superstructure comprises 10 deck girder spans, then 10 deck truss spans (above), and finally, 3 deck cantilever spans. The signature feature in the middle of the bridge is the 1,600-foot-long suspension span running across the main commercial shipping channel. Then, the bridge continues eastward over a series of 9 deck cantilever trusses, 3 through cantilever trusses across a secondary shipping channel (below), 18 deck girder spans, and finally, 37 deck beam spans, before it terminates as a raised rock- and earth-filled causeway running to the shore. (Both, courtesy of George Jenkins.)

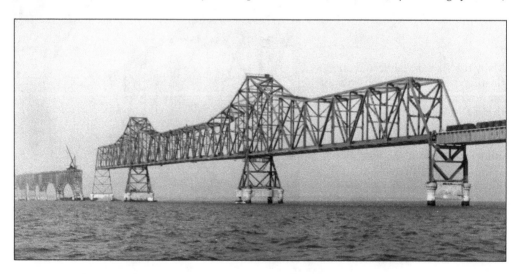

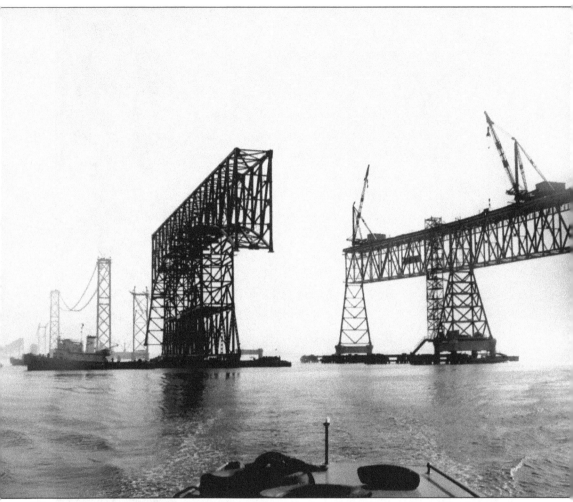

The steel trusses employed on the bridge, such as the deck truss seen here, are a complex intersection of steel beams and structural support braces. They were designed to carry the roadway either atop or through the spans, depending on their purpose. The truss in this photograph, seen minutes before it was fixed in place, was installed using an ingenious method involving the Chesapeake Bay tides. The truss was supported on temporary truss work, floated by barge onto the site at high tide, nudged into position by tugboat, and then, with the truss hovering inches above its intended place, the barge was filled with water. The barge began to sink, whereupon the truss atop it gently lowered into position. The process was repeated with subsequent sections of the bridge until the last truss was floated, lowered, and bolted into place. Visible in the distance are the tall suspension towers and cables, which were also being constructed during this time. (Courtesy of the Hagley Museum.)

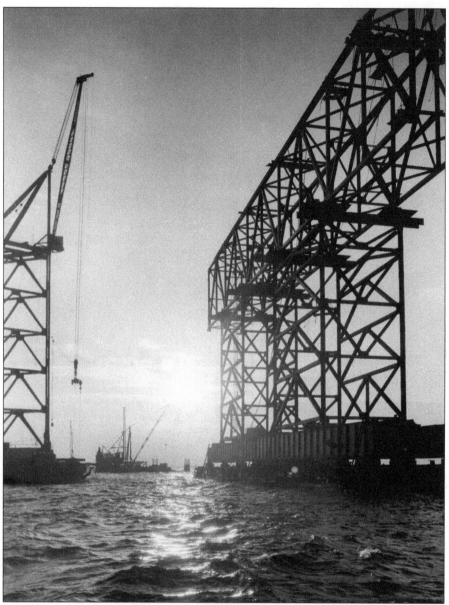

Barging truss sections into place was not always a flawless operation. In December 1950, during the early stages of the steel superstructure erection, a winter storm damaged a barge loaded down with bridge girders and sent it adrift. The barge broke loose from its mooring, meandered about six miles northeast of the construction site, and sank in about 30 feet of water. No one was aboard the runaway barge and there were no injuries reported, but it was feared losses caused by the storm might exceed $500,000. Recovery efforts ensued, and during the three-week search, a fathometer—an electric sound-echo device capable of registering unusual differences in water depth—was brought in to plumb the depths of the bay, while a plane mounted with a magnetometer that might detect the submerged steel flew over the area. When the wreckage was finally located, divers went down to recover the missing girders one at a time to reuse them. The tedious retrieval effort was worthwhile because it saved money, and replacing the steel would have delayed bridge construction. (Courtesy of Aubrey Bodine.)

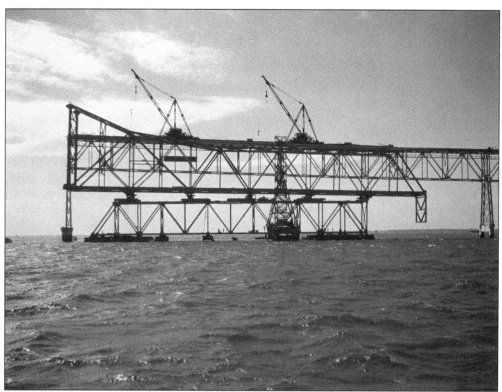

Another mishap occurred during a squall one year later in December 1951. A 480-foot cantilever truss, like the one seen here, broke loose from its towing tugs, struck a bridge support truss and floated helplessly down the bay. The accident occurred during high winds and waves, when a tug's towing line had snapped. The moment the barge struck the bridge support, several of the workmen aboard the barge jumped over the side, fearful that the giant 1,500-ton truss might collapse on them. After nicking the bridge, the runaway barge floated eastward and ran aground just off Kent Island near the Eastern Shore. Several weeks later, the errant truss was refloated, inspected for damage, repaired, and installed into the bridge as if the accident had never occurred. (Above, courtesy of the Hagley Museum; right, courtesy of the *Baltimore Sun*.)

480-FOOT SPAN SLIPS ITS TOW, STRIKES BRIDGE

Damage To Bay Structure May Run To $100,000; Barges Go Aground

A 480-foot span for the Chesapeake Bay Bridge yesterday broke loose from towing tugs, struck the supporting trusses of the bridge, and eventually went aground on the Eastern Shore near the Matapeake ferry slip.

No one was injured.

There was no immediate estimate of the damage to the bridge structure, but one engineer said the damage might run to more than $100,000.

The accident occurred about noon in a high wind when a towing line, attached to one of the tugs, snapped. This made it impossible to maneuver the 1,500-ton structure which rose about 130 feet above the water level, and the span gradually drifted eastward.

Workmen Jump Overside

The span, which was being floated on four barges, struck the bridge near piers No. 36 and 37. When this happened, several of the workmen jumped over the sides of the barges, apparently fearing that some of bridge superstructure might fall on them.

43

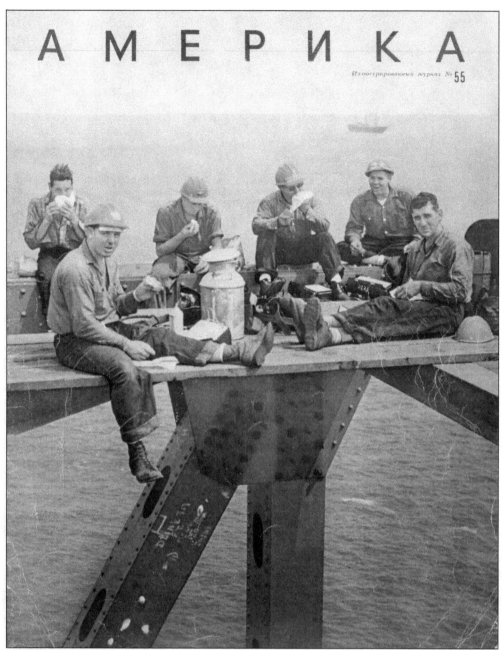

А М Е Р И К А

Иллюстрированный журнал № 55

The building of the Bay Bridge was an ambitious feat of engineering, causing overseas audiences to take note. During construction, the Russian magazine seen here published an extensive photographic essay on the bridge as it went up, focusing primarily on the work being done by laborers in all departments. Although some of the most up-close and vivid photographs of the project appeared in this magazine, the Russian photographers seemed to be more concerned with documenting the workers than the bridge itself. The intimate photographs depict the dangers of the work and the camaraderie between workers whose paths might never have crossed. Here, a construction crew is astonishingly at ease taking a lunch break on a wooden platform atop steel girders high above the waters of the bay. (Courtesy of the Maryland Transportation Authority.)

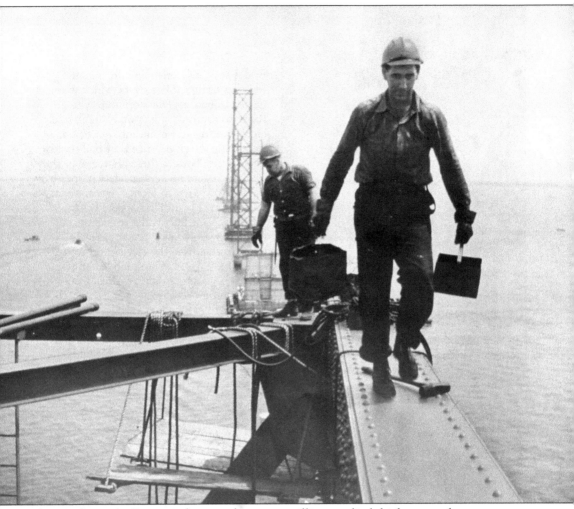

As seen here, the Russian photographers were willing to climb high up on the structure to document the project. Neither safety belts nor nets were used during construction of the Bay Bridge. However, there were a few safety measure taken by the men. The crews seen here, called ironworkers, were instructed to wear pants without cuffs and to tuck in their shoelaces to avoid tripping. The foremost tool in an ironworker's belt was nerve, followed by the ability to climb, crawl, and shimmy around steel beams hundreds of feet in the air. Working at such heights was harrowing, and with no safety harnesses or lanyards, men kept both their foothold and trepidations in check. Even so, accidents happened. Four workers actually died building the Chesapeake Bay Bridge, and there were many close calls. The daily dangers on the job included falling roughly 200 feet from an I beam, being washed from one of the barges in a storm, or getting struck or crushed by the construction materials. (Courtesy of the Maryland Transportation Authority.)

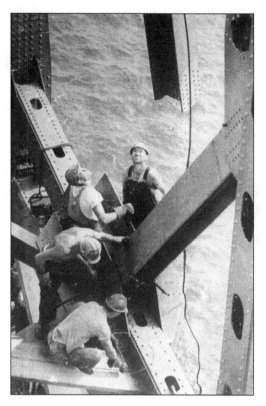

Bridge sections were manually fastened together using red-hot rivets, which were heated in burners four stories up. The Russians captured this team of "high steel men" riveting an I beam into place and inspecting the rivets once they had cooled. Once again, both of these photographs show that there were no nets or safety harnesses in use in those days. In such an environment, mishaps were bound to happen. Rookie rivet inspector Bob Miller recalls the day that fellow ironworker Frank LaGarry missed a step from the elevator onto a truss and fell 197 feet. LaGarry landed on the elevator's counterweight and died instantly. The whole crew were given the rest of the day off. Miller recalls that the accident was not a matter of negligence, but simply that LaGarry had missed the step he and his coworkers used every day. It could have been any one of them. (Both, courtesy of the Maryland Transportation Authority.)

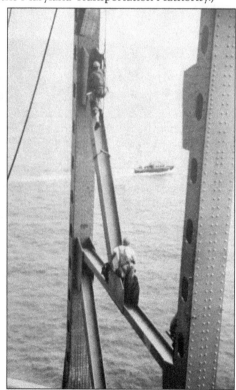

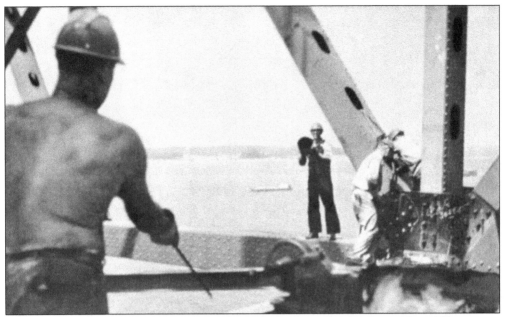

Riveting teams were organized in groups of four. The leader, called the "burner," would heat rivets and toss them about 10 yards to the "catcher," who would snatch each rivet out of the air with a funnel-shaped bucket. The catcher would then place the rivet in the hole for the "bucker" to hold in place while the "driver" used a rivet gun to hammer the rivets and bond the steel beams into a structure. (Courtesy of the Maryland Transportation Authority.)

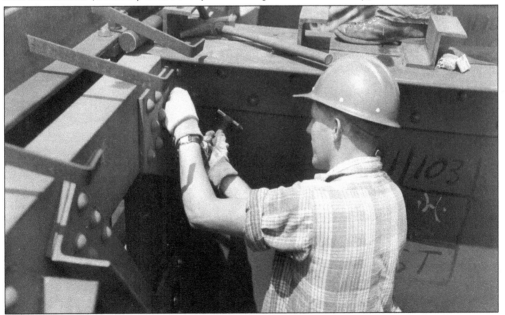

Once the riveting team had completed a section of the Bay Bridge's superstructure, rivets were inspected, and defective ones were cut out and replaced. A "rivet punk" was the apprentice who supplied two or three different gangs with all the materials necessary to carry out the process. Former rivet punk William Cusimano fondly remembers working on the bridge as he transitioned to adulthood. (Courtesy of George Jenkins.)

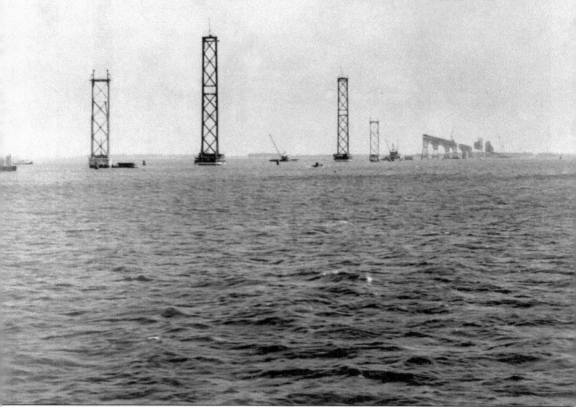

In the gubernatorial election of 1950, Gov. William Preston Lane Jr. was defeated in his bid for reelection by Theodore R. McKeldin. During the campaign, the Bay Bridge had been criticized and derided as "Lane's picket fence across the bay." But once in office, McKeldin supported the construction project and helped guide it to completion. By the end of April 1951, almost the entire substructure was ready for the superstructure to grow on top of it, and work began on the main towers for the suspension span. In this photograph from November 1951, it may appear as if the bridge was being assembled in a haphazard manner, but steel erection followed a defined plan. In the foreground, the suspension towers were being built, while in the distance several truss sections can be seen already installed. When the towers for the main span were complete, men would begin stringing the suspension cables from tower to tower and hanging roadway truss sections. (Courtesy George Jenkins.)

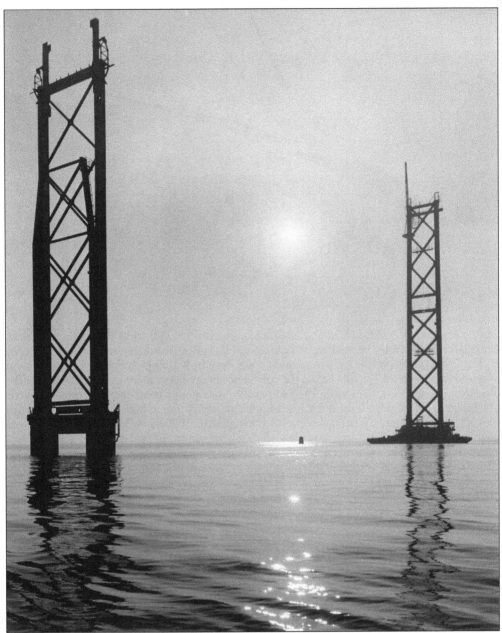

The resident engineer for the Chesapeake Bay Bridge was Elmer White, a man who had built 39 bridges in his career—the Bay Bridge was his 40th. White's job was to ensure that the bridge was built strictly according to plans. Early on in the project, he was moved to say, "I love bridge building. It is pleasing to me to see a big bridge take shape and stand out against the sky above the water. This bridge is going to be a real beauty, and I'm going to watch it grow day by day." One of the more unusual problems facing the engineers planning the bridge—one requiring a remarkably precise solution—was that due to the curvature of the earth, the water surface in the middle of the bay is about two and a half feet higher than at either shoreline. To compensate, engineers positioned the two main towers 1,600 feet apart at the surface of the water, but 1,600 feet and one quarter of an inch apart at the top. (Courtesy of Aubrey Bodine.)

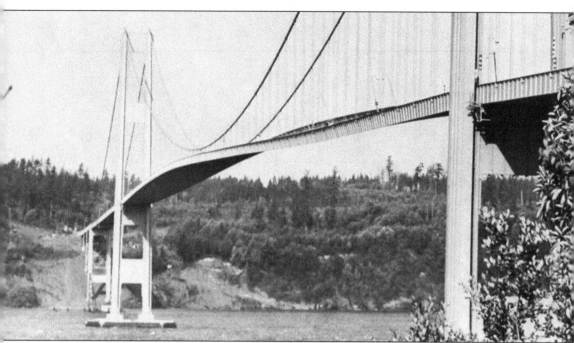

Suspension bridges must be designed to hold up against any number of natural forces acting upon it. The Tacoma Narrows Bridge, a suspension bridge built in Washington State over Puget Sound, was opened for service 12 years before the commencement of operations at the Chesapeake Bay Bridge. It opened to traffic in July 1940 with a flaw that almost immediately became apparent: the bridge deck's aerodynamics made it susceptible to undulation in high winds, a disconcerting characteristic that earned it the nickname "Galloping Gertie." Finally, on November 7, 40-mile-per-hour wind gusts caused the deck to pitch wildly, and eventually, the structure began tearing itself apart. This photograph was taken that day, when Galloping Gertie had begun to twist and sway above the water. Engineers define this phenomenon as aeroelastic flutter, which occurs when the wind-forced vibrations of a structure (the bridge deck) match its natural resonant frequency and the structural instability ends in catastrophe. (Courtesy of the University of Washington Library.)

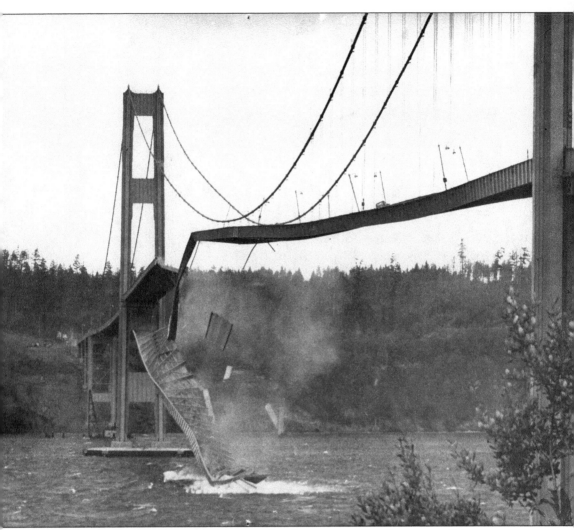

In this photograph, Galloping Gertie is pictured in the very act of breaking apart. One prescient bridge engineer, Dexter R. Smith, had described the bridge's flaws to a national engineering conference six months prior to its collapse. Smith predicted that under the right conditions—a wind of 40 miles per hour against the bridge's solid plate side girder—the bridge would likely fail. "When Smith finished," according to reports, "the stunned audience sat in silence. Then, they rose to their feet, hollering at Smith and demanding he get out." Dexter Smith went on to design and build the replacement bridge over the Tacoma Narrows, and to ensure against a Galloping Gertie–like mishap over the Chesapeake Bay, Smith was also brought in to consult on that project. They decided to build special vents into the bridge's suspension roadway to counter the effects of the high winds that often rose up in the bay. (Courtesy of the University of Washington Library.)

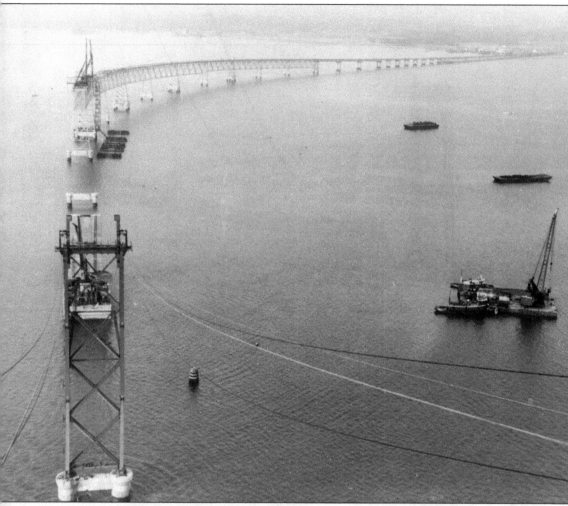

The deck of the Chesapeake Bay Bridge is 186 feet above the water where it crosses the main shipping channel, and the suspension towers ascend to a height of 354 feet. This photograph, taken from the highest point on the fledgling bridge in December 1951, captures the truss sections stretching outward and upward from Sandy Point. It also shows the rigging strung between the suspension towers to create a temporary walkway that workers used to run the suspension cables. The suspension section of the bridge was designed to carry the roadway 1,600 feet across the main shipping channel. Locating the bridge in relation to that fixed channel was a delicate issue. The J.E. Greiner engineers designed a clever solution, the graceful curve, seen taking shape here, for which the bridge is now famous. (Courtesy of George Jenkins.)

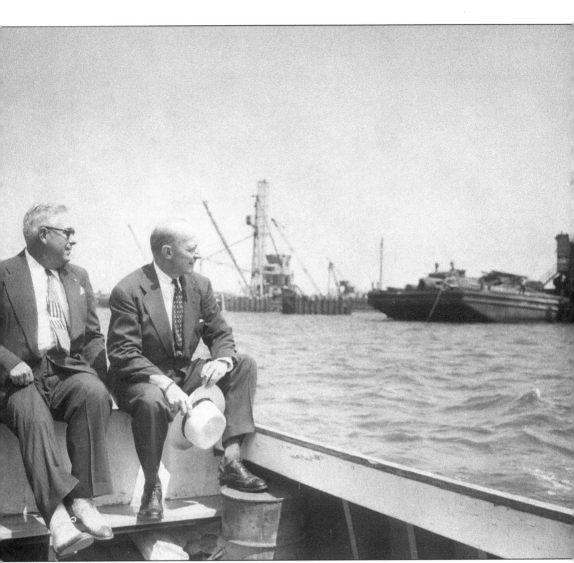

In this 1950 photograph, Maryland governor William Preston Lane Jr., accompanied by Paul E. Tignor, a Baltimore contractor, is reviewing construction progress from aboard a boat. The Chesapeake Bay Bridge had been controversial and was reviled as "Lane's folly" for the governor who had risked his political career to champion the bridge. Though the bridge was first proposed in the early 1900s, plans languished until Governor Lane took office in 1947 and pushed it through despite detractors who predicted financial ruin, the overrunning of the Eastern Shore, and the impossibility of building such a lengthy span. Years later, on November 9, 1967, with the bridge up and successfully running, a crowd of 250 huddled in overcoats at the span and officially renamed it the William Preston Lane Jr. Memorial Bridge in memory of the governor who helped to create it. Lane had died just nine months before, so his widow accepted the honor in his place. Today, it remains the official name of the bridge. (Courtesy of the *Baltimore Sun*.)

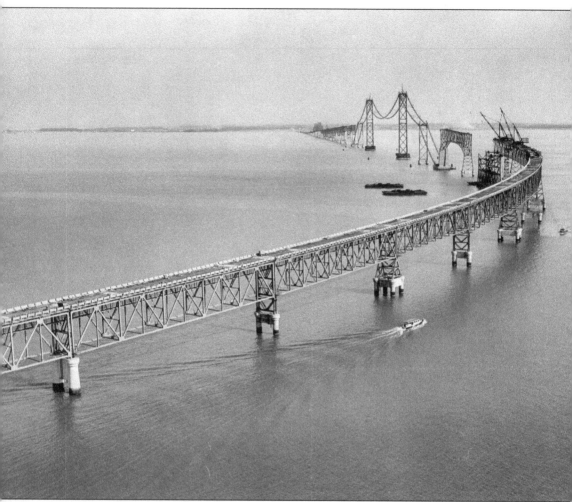

Restricted by the technology of the day, workers had to construct the bridge spans piece by piece. Crane operators lowered steel sections into place, and they were then joined to the previous fragment with red-hot rivets. It was a process that called for surgical precision, but crane operators in their cabs never had a clear view of the joining site. In response to this issue, directors were put in place to be the crane operator's eyes. They were positioned within view of the action and, using a remote-control box, would send signals to correspond with various lights inside the crane's cab. The operator would respond by pushing pedals and lifting levers to manipulate the crane's direction and lower the beams into place. Given that neither the beam itself nor the workmen were within the crane operator's sights during the procedure, the opportunity for a tragic error was great. This image shows several of the cranes as they operated from atop the bridge's superstructure. (Courtesy of George Jenkins.)

Three

HEYDAY OF THE FERRY

Before the bridge, the only way to cross the Chesapeake Bay was by boat, a method of travel that was destined to change in the 20th century with America's transportation revolution. On land, people gave up their buggy whips in favor of horseless carriages, and with the growth of automobile culture came the need for new and better roads. Maryland's old dirt tracks and oystershell roads would not do. Citizens wanted paved roadways, and in the relentless march of progress, more and more miles of them were gradually built to meet their demand. Travelers grew accustomed to the freedom of driving on their own schedules, and when it came to crossing the bay, they utilized a network of ferryboat lines that sprang up in response. From 1919 through 1952, automobile ferries were the sole east-west link between the two Maryland shores, the only alternative to the long and arduous drive up and around the top of the bay. On the Eastern Shore, truckers grew to rely on the ferries to get their freight to market, so much so that the old bay schooners, which for generations had hauled seafood and produce to distant buyers, could no longer compete with the trucks that made the round-trip crossing faster and cheaper on ferries. Marylanders on the Western Shore relied on car ferries to escape to the beaches, amusement parks, dance halls, and fishing holes in the east. After making the ferry crossing, they were swept by rail from the ferry terminals to hamlets down the Delmarva Peninsula, like Easton and Salisbury, Maryland, or the coastal resorts of Ocean City, Maryland, and Rehoboth Beach, Delaware. For three decades, the ferry system flourished. Ferry lines expanded with additional routes and more frequent runs to keep up with the burgeoning streams of motorists, but their capacity was finite, and by the late 1940s, the ensuing logjams drove motorists to join the clamor for a better way to cross the bay. A bridge was inevitable, but until it came, riding the ferry was a way of life.

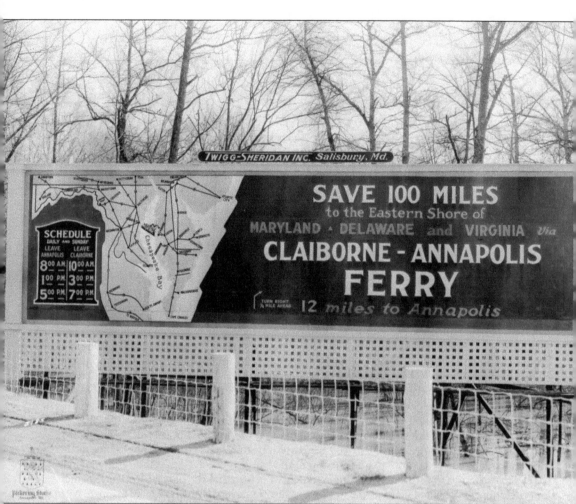

Prior to the opening of the Chesapeake Bay Bridge in 1952, the ferries were a good, albeit temporary, solution to the shuttling of passengers and freight from one side of the bay to the other. This billboard for the Claiborne-Annapolis Ferry Company, probably located along Ritchie Highway to the northwest of Annapolis, Maryland, urged Eastern Shore motorists to "save 100 miles" and to save time by taking the ferry. The accompanying road map starkly illustrates the strenuous journey faced by Eastern Shore travelers who wished to go to Baltimore. They had to drive northward up the Delmarva Peninsula to Elkton to the top of the Chesapeake Bay and then down the other side to reach Baltimore and the western part of the state. With only "12 miles to Annapolis" from the Eastern Shore, the Claiborne-Annapolis ferry was rightly touted as a faster, more efficient way to get from one side of Maryland to the other. (Courtesy of the Chesapeake Bay Maritime Museum.)

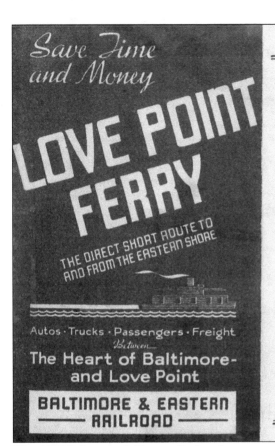

This 1937 Baltimore & Eastern Railroad flyer promoted the ferry it operated between "the heart of Baltimore and Love Point." Love Point, the eastern terminus of the ferry, was a rural community at the northern tip of Kent Island, which had grown into a modest resort in the early decades of the 20th century. A network of railroad lines linked Love Point with the various resort towns of the Delmarva Peninsula. The accompanying map "shows the way to shorten the way to and from the Eastern Shore." Using this transportation system, ferry patrons crossed the bay from downtown Baltimore and either stopped at Love Point for its hotel and entertainments or hopped aboard the railroads that continued both eastward and southward all the way to such popular destinations as the resorts of Ocean City or the seafood harvesting capital of Crisfield. (Courtesy of the Kent Island Heritage Society.)

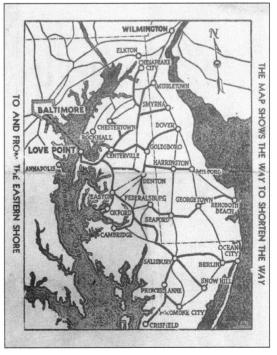

This advertisement of the Baltimore & Eastern Railroad, a subsidiary of the Pennsylvania Railroad, exhorted travelers to "save time and money" and "cross the bay the Love Point way." The Love Point Ferry was officially named the *Philadelphia*, but passengers seldom called it that. It was nicknamed "Smokey Joe," short for Josephine, for it would belch a cloud of black smoke from its twin smoke stacks as it crossed from Baltimore to the northern tip of Kent Island. The dark smoke resulted from the cheap bituminous coal that was used by the Pennsylvania Railroad as a cost-saving measure. Called "a squat and dumpy double-ender" by one local journalist, the *Philadelphia* was a coal-fired steamer that began plying the Chesapeake Bay in 1932 and made its final run in August 1947. Smokey Joe had a blazing coat of paint that was "red enough to enrage a sea cow, let alone a bull." (Both, courtesy of the Kent Island Heritage Society.)

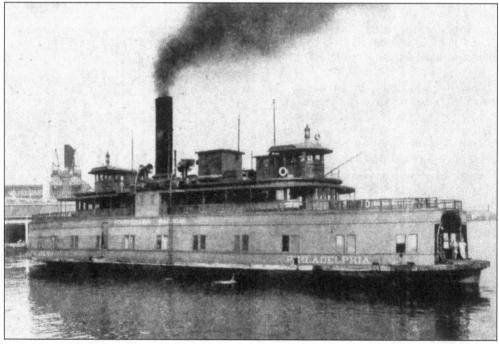

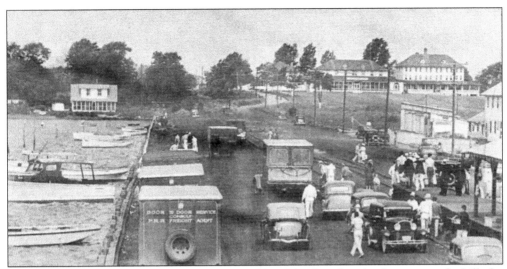

This is a view of the bustling Love Point pier on Kent Island, and in the distance on the hill, the town's resort hotel. The ferry departed from Light Street in Baltimore and arrived in Love Point in 2 hours and 20 minutes. Off-loaded motorists and truckers either continued their journey down the Eastern Shore or stayed and enjoyed the charms of Love Point. (Courtesy of the Kent Island Heritage Society.)

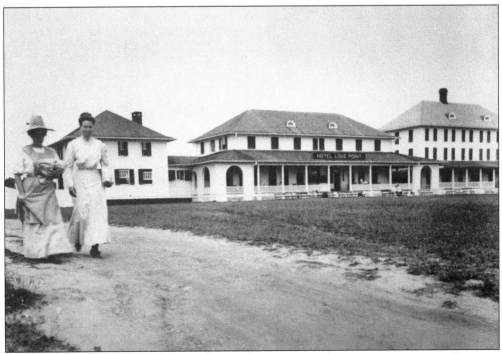

The Love Point Hotel, built around 1900, was a notable Kent Island attraction. It was advertised as "Maryland's grand hotel" and featured broad verandas and wraparound porches. It was a favorite gathering spot for Maryland politicians and a popular hotel for honeymooners. (Courtesy of the Kent Island Heritage Society.)

LOVE POINT HOTEL

LOVE POINT, MD.

Will Be Open Saturday
June 11th, 1932
For the Season

REASONABLE RATES

Adults, $15.00 per week Children, $7.50 per week

Now booking accommodations for the 1932 Season.

Real Maryland Sea Food Dinners.

Fine Salt Water Bathing with bath house facilities.

FERRIES LEAVE PIER 5, LIGHT STREET

SCHEDULE

	Daily	Daily	Daily ex. Saturday
Lv. Baltimore	7.00 A. M.	2.30 P. M.	8.30 P. M.
Ar. Love Point	9.20 A. M.	4.50 P. M.	10.50 P. M.
	Daily ex. Sunday	Daily	Daily
Lv. Love Point	1.00 A. M.	10.40 A. M.	5.30 P. M.
Ar. Baltimore	3.20 A. M.	1.00 P. M.	7.50 P. M.

Ten-day round trip ticket, Baltimore to Love Point and return, $1.00.

One-way ticket, 65 cents.

Round trip tickets sold on Friday and Saturday, good to return until Monday, 75 cents.

Round trip tickets sold on Saturday afternoons and Sunday afternoons round trip, 50 cents, good for the afternoon only.

JOHN H. ROBINETTE, *Prop.*

On Saturday nights, the Love Point Hotel lobby was transformed into a dance hall with music performed by an eight-piece orchestra. Local resident Bill Denny remembered the following about his father in the 1940s: "[He] worked all day on the farm and couldn't wait to get home and take a bath and get dressed up, in a tie and a coat" and then walk the mile and a half down Love Point Road to the dance hall. With maybe $1.50 in his pocket, he would get dinner for 45¢ and then sit back to admire all the girls, who likely sailed over from Baltimore on the Smokey Joe. "When the orchestra played and the big dance floor was crowded," recalled Denny, "he'd work up the nerve to ask one of those girls if she'd dance with him. And they'd dance and have a good time and all. Then, of course, he had to be home by ten o'clock in order to get up at 5:00 a.m. the next morning and milk the cows!" (Both, courtesy of the Kent Island Heritage Society.)

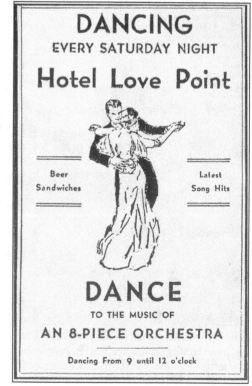

DANCING
EVERY SATURDAY NIGHT

Hotel Love Point

Beer Latest

Sandwiches Song Hits

DANCE
TO THE MUSIC OF
AN 8-PIECE ORCHESTRA

Dancing From 9 until 12 o'clock

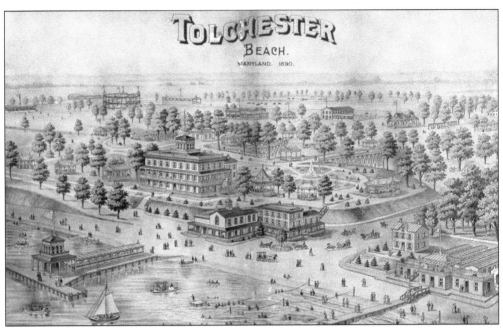

Another popular Eastern Shore destination was the amusement park at Tolchester Beach, Maryland. Established in 1877 by the Tolchester Steamboat Company, the park touted itself as "Maryland's Chesapeake Bay playground" and was reached via a two-hour steamboat ride directly across the bay from downtown Baltimore. Tolchester was convenient enough that city residents routinely escaped the summer heat by traveling there, even if only for the day. (Courtesy of the Kent Island Heritage Society.)

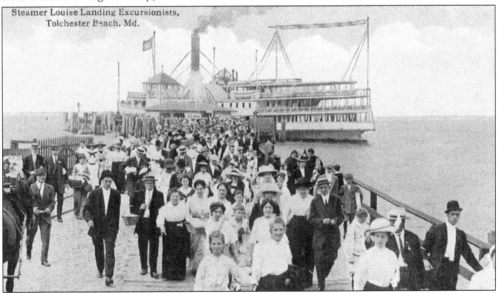

Urban day-trippers departed Baltimore's Light Street wharf in the morning aboard side-wheel steamers, like the *Louise*. They reached Tolchester Beach in a breezy two hours. A typical outing of the time included swimming at the beach, riding the amusement park's roller coaster, enjoying a picnic, or fishing, and at the end of the day, visitors boarded the ferry to return home. (Courtesy of the Chesapeake Bay Maritime Museum.)

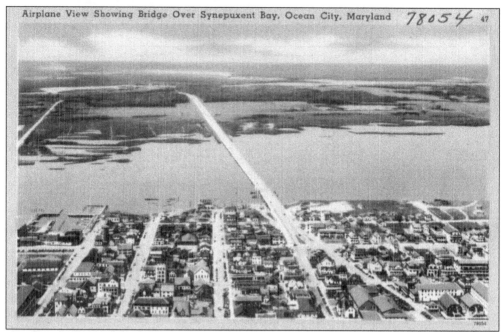

The Eastern Shore was long seen by Western Marylanders as a destination for rest, relaxation, and escape. With the prosperity America experienced following World War II, families could afford a suburban house and car, sometimes even two cars, and had enough leisure time to get away. Increasingly, they crossed the bay, especially on summer weekends, to reach Ocean City, the booming beach town seen here. (Courtesy of the Boston Public Library.)

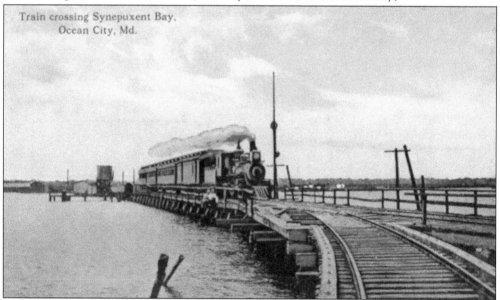

Once vacationers were ferried across the Chesapeake Bay, rail lines, like the famous Ocean City Flyer, which ran down the Delmarva Peninsula, were ready to highball them to the seaside resorts. This postcard depicts a locomotive pulling its coaches over the bridge at Synepuxent (now Sinepuxent) Bay, located just before reaching Fenwick Island, the barrier spit that had become Ocean City. (Courtesy of the Chesapeake Bay Maritime Museum.)

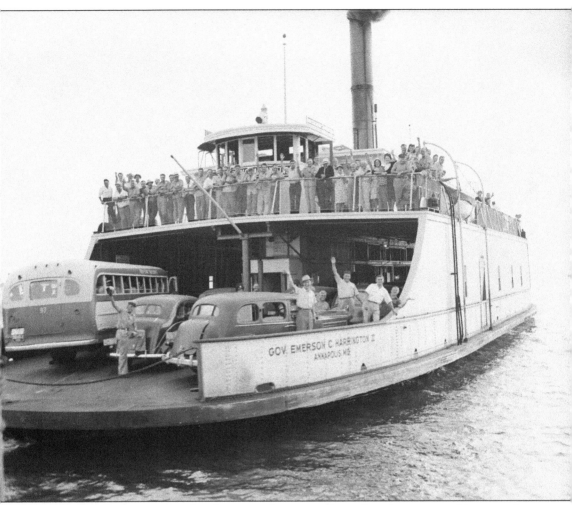

Before the Bay Bridge was completed, crossing from one side to the other meant taking one of five ferryboats plying the bay. The *Gov. Emerson C. Harrington II* ferry is seen here as it departs Claiborne, Maryland, an important terminal for the cross-bay ferries. George W. Phillips took a job with the ferry services in 1928, at the age of 26, and rose to become the assistant general manager of the Claiborne-Annapolis Ferry Company. At his retirement, in an article in the *Anne Arundel Living Sun* newspaper, he recalled that "we were pioneers in opening the Eastern Shore." Yet, even with ferries cruising back and forth nearly 24 hours a day, seven days a week, there were frequent backups. "It's a good thing the bridge was built when it was," Phillips said; "we couldn't handle the traffic." Phillips estimated that in the final year of operation, all the ferries working the bay carried approximately 1.1 million vehicles and hundreds of millions of people. (Courtesy of the Chesapeake Bay Maritime Museum.)

The truck drivers in this photograph are waiting for the next boat. Chesapeake Bay ferries were not just facilitators of recreation but also of commerce. Trucker Ed Nelson recalled the long trips he made in the late 1930s and early 1940s to transport seafood from the Eastern Shore to Baltimore: a journey made far easier by the emergence of the Chesapeake ferries, like the Smokey Joe. "The restaurants open at 5:00 p.m. They want their fresh crabs and oysters. It has to be there," Nelson recalled. He would drive his two-ton truck from the White and Nelson packing house in Cambridge, Maryland, to Love Point; board the Smokey Joe ferry at 1:20 in the morning; unload at Baltimore's Light Street Market at 4:00 a.m., and complete the return trip to Cambridge by 1:00 in the afternoon. It was at least a 12-hour day for Ed Nelson. (Courtesy of the Chesapeake Bay Maritime Museum.)

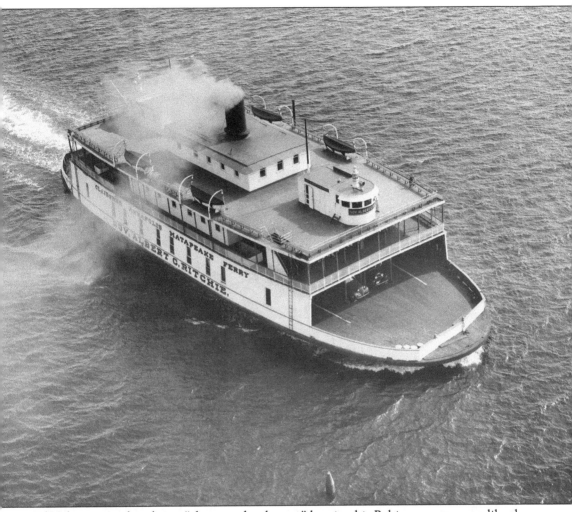

Ed Nelson remembers being "always under the gun" keeping his Baltimore customers, like the A&P grocery stores, supplied with fresh seafood and produce. Commercial trucks were always overloaded and had to drive over "turkleback" roads ("turkle" in the rural Eastern Shore meant "turtle"), the bumpy, unpaved roadways that battered the trucks as they raced to catch the next ferry. "At high tide, water often came up over the road, and saltwater and mechanical brakes don't mix. Many times the only brakes we had was downshifting," said Nelson. The damage was often extensive enough to warrant replacing the vehicles every two years. According to Nelson, "there were lots of seafood packers doing the same thing I was doing," truckers hauling loads aboard ferries, like the *Gov. Albert C. Ritchie* seen here. He lamented, "The biggest disappointment was coming down the hill at Love Point and seeing the ferry just leaving the dock, or being next in line as they put down the gate." (Courtesy of the Chesapeake Bay Maritime Museum.)

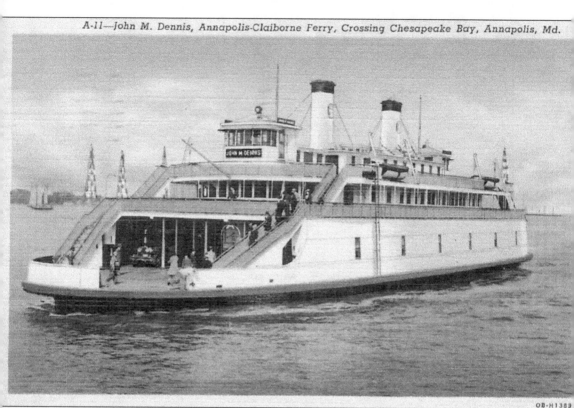

Ferry passengers who wished to commemorate their bay crossing could pick up a postcard, such as this one of the *John M. Dennis* gliding past the radio towers that stood on the Western Shore near Annapolis. The ferries ran a rigorous schedule. George W. Phillips, who worked on the ferry system from 1928 until the bridge opened in 1952, said, "The ferries ran 46 round trips daily. They were out of service only from 2:00 a.m. to 4:00 a.m. for refueling, taking on water and housekeeping." Trucker Ed Nelson, who remembers the ferries fondly, said, "There was a little romance to the ferry. You'd go upstairs on the upper deck, where you had a two-story view looking out on the bay. It was scenic and enjoyable, with a bay breeze blowing over the deck." Phillips also recalled that, once aboard, one could get "everything from soup to nuts for 75¢. We had good Eastern Shore cooking." (Courtesy of the Chesapeake Bay Maritime Museum.)

Shown here are a few of the men who piloted the *John M. Dennis* from Matapeake to Sandy Point and maintained ferrying as largely a family business. Many of the ferry's captains and mates were related to one another. The Higgins boys—three brothers and two sons—were dubbed the "Higgins Navy" by locals. (Courtesy of the Kent Island Historical Society.)

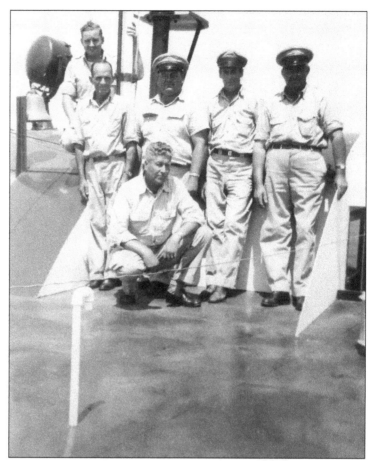

Cousins Pat (left) and Dan "Greely" Higgins (right) considered the vessels "a home away from home." They would direct traffic on and off the ferry, clean the boat, and enjoy their meals from the ferry's kitchen. On days when it was not running, they would even paint it. When the Bay Bridge was opened, it rendered the ferries redundant, and Pat and Dan were witness to the end of the Higgins Navy. (Courtesy of the Kent Island Historical Society.)

67

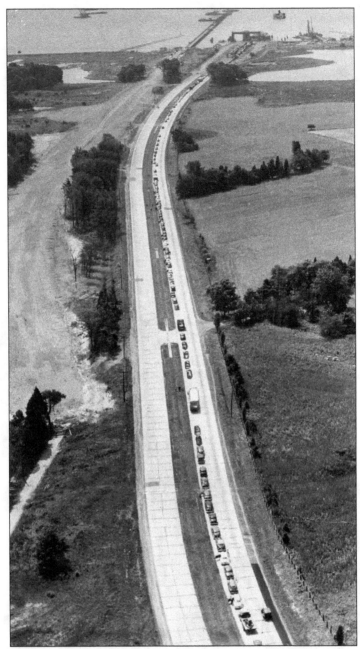

This 1950 photograph, taken of the US Route 50 approach to the Sandy Point Ferry Terminal, illustrates the recurring traffic tie-ups faced by motorists trying to cross the bay. Neither the frequency of runs nor the capacity of the ferries were sufficient to minimize these backups, which, especially on weekends, often extended a mile or more from the pier. Here, cars are backed up from the ferry terminal at the top of the photograph all the way down the highway and out of the frame at the bottom. Motorists appear to have endured the inconvenience amicably. As ferry worker George W. Phillips recollected, "There were long waits on the weekends. But they waited patiently. With an hour or so to kill, motorists used to spread blankets beside the highway and take a sunbath." (Courtesy of the *News American*.)

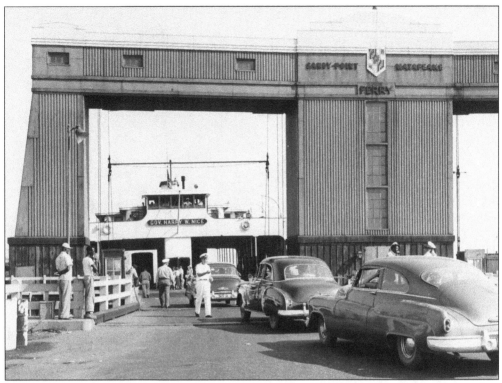

Most of the ferries were named for Maryland governors. This 1952 photograph depicts cars boarding the *Gov. Harry W. Nice* at the Matapeake Terminal on Kent Island. It was partly because of the finite capacity of ferries, and the fact that more and more people had cars, that public pressure built on Maryland's political leaders to find a way to bridge the bay. (Courtesy of the Kent Island Historical Society.)

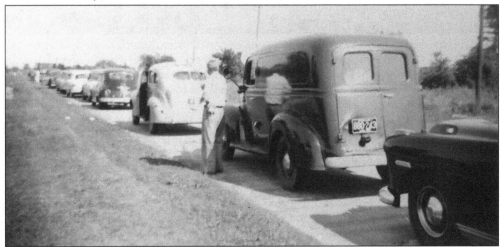

Motorists in this 1952 photograph waited in line for their turn to cross. Ferryman Pat Higgins remembered the frustrations of vacationers returning home from the seaside resorts, saying that "all the pretty girls were joyful going over to the beach. But coming back all sunburned, sitting in a traffic jam for an hour or two waiting for the ferry, it was a different story. They weren't as joyful coming back." (Courtesy of the Kent Island Historical Society.)

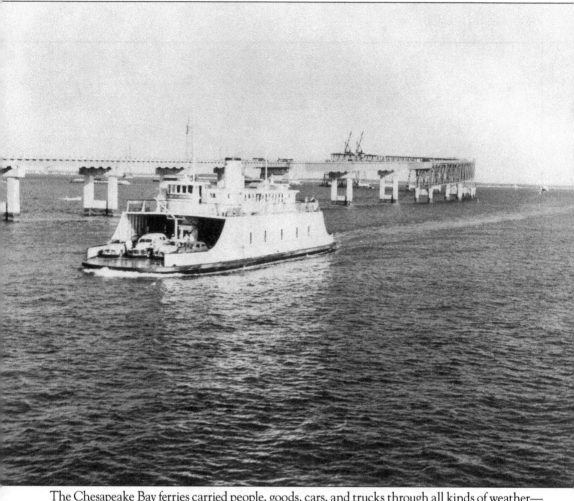

The Chesapeake Bay ferries carried people, goods, cars, and trucks through all kinds of weather—rain and windstorms in summer, and fog, snow, and ice in winter. The ferry employees were typically former watermen who started as deckhands and worked their way up the ranks. Boat captains had the reputation for being nimble and able to thread the needle of the narrow 150-foot-wide shipping channels, keeping the cumbersome ferryboats away from the bay's muddy shallows. George W. Phillips recalled the skill with which they guided their vessels home as follows: "Sometimes, in foggy weather, captains literally had to 'smell' their way into port." With navigating the ferries deeply ingrained in their character, Phillips explained, "They were dyed-in-the-wool." On August 4, 1951, when this photograph was taken, the Chesapeake Bay Bridge was at the height of construction, and each time a ferry glided past the concrete piers, it was one step closer to its own obsolescence. (Courtesy of the Maryland Transportation Authority.)

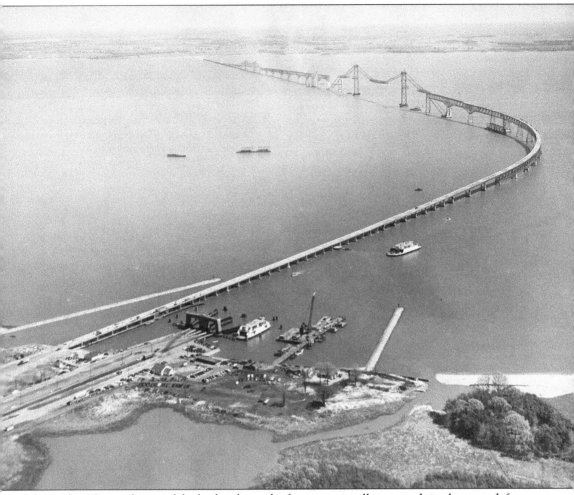

This early-1952 aerial view of the bridge shows the ferry system still very much in charge and, for the time being, the bay still very much in the way. One off-duty ferry can be seen parked at the Sandy Point Terminal, while another vessel finishes its crossing alongside the soon-to-be-opened bridge. As the ferries made their final runs, passengers could wave at the construction crews, who were busy applying the finishing touches to the bridge. Crane operators were hoisting the final suspension sections, the steelworkers and rivet men were securing them into place, concrete pourers were paving the 4.35-mile roadway, electricians were installing navigational lighting and fog signals, and road crews were adding collision curbs and steel safety railings to the roadway. But just before the new span was open, a renegade ferry veered from its usual path, and seemingly with a mind of its own, sped straight for the new structure. (Courtesy of the *News American*.)

On July 7, 1952, three weeks before the bridge opening, in one final irony, or perhaps act of revenge, the *John M. Dennis* broke her steering cable, drifted out of control, and rammed one of the bridge pilings, ripping a hole in the vessel's deck. The ferry was loaded with a holiday crowd of passengers and automobiles returning from the long Fourth of July weekend. (Courtesy of the *Baltimore Sun*.)

The impact gouged a giant gash in the car ferry's steel deck, bruised some 20 passengers, damaged nine cars, and caused a two-mile traffic jam back on shore. While nobody was seriously injured in the collision, and the bridge itself was not damaged, the accident did add a tongue-in-cheek headline to the local annals of Chesapeake Bay folklore— "Ferry bites bridge!" (Courtesy of the Chesapeake Bay Maritime Museum.)

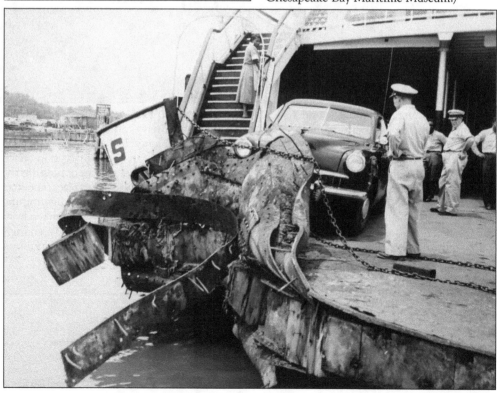

Four

A UNITED STATE

At the onset of 1952, it had been roughly two years since the first surveying crews floated out into the middle of the Chesapeake Bay to begin building a bridge. In an impressively short period of time, sturdy foundations had been sunk into the Chesapeake mud; massive cables had been wound and strung over the main shipping channel; stalwart metal trusses had been hoisted and riveted into place for the roadway; and some portions of the road, the few thousand feet that extended out from both shores, had already been paved. As the world's longest continuous over-water steel structure was nearing completion, plans were taking shape for a grand opening ceremony on July 30, 1952. At long last, Maryland, a state divided into two virtual islands, would be reunited. The bridge was christened with a celebratory parade on a characteristically hot midsummer morning, beginning with the firing of a salute on the Western Shore and concluding with the singing of "Maryland, My Maryland," the official state song, on the Eastern Shore. From an architectural standpoint, the bridge was an instant success. Ordinary citizens admired its graceful curve and soaring suspension towers, while engineers esteemed its technological achievements. In a sense, the bridge returned Maryland to its old maritime days of the 18th and 19th centuries, when the Chesapeake Bay was simply traveled by boat, and citizens of the two shores felt a connection and affection for one another. Yet, some residents of the Delmarva Peninsula wrote letters to the *Baltimore Sun* worried about "the coming invasion of the Eastern Shore" by "hordes of tourists, vacationists and out-for-the-day motorists"—outsiders who would undoubtedly alter their way of living. As one writer lamented, "Progress, in whatever guise, always takes a heavy toll on the quaint and familiar." But when the ribbon cuttings, proclamations, and parades of the opening ceremonies finally ended and the remarkable stretch of concrete and steel conveyed a stream of vehicles across the Chesapeake Bay, there was no turning back.

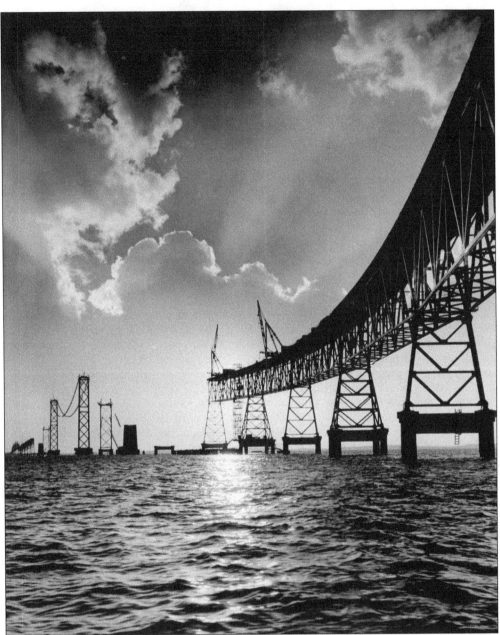

This dramatic photograph, looking eastward toward the bridge with the rising sun behind it, was captured in 1951 by Aubrey Bodine, one of Maryland's finest and most well-known photographers. Though construction was far from finished, the image projects the monumental nature of the undertaking. In the six months after Bodine's photograph, workers had pushed the structure farther outward from the shorelines until the two segments met in the middle to fully span the bay. The photograph shows, in the distance, the two main suspension towers straddling the main shipping channel and the suspension cables that would eventually hold up the roadway being strung from tower to tower. The 1,600-foot expanse between the two towers was a distance mandated by the US Army Corps of Engineers to ensure that freighters sailing to and from the Port of Baltimore would safely pass, even in treacherous weather or the dead of night. (Courtesy of Aubrey Bodine.)

Engineers devised the method, seen here, to string suspension cables across the shipping channel. Working atop the east suspension tower—the highest point on the bridge at 354 feet—men stretched cable strands between the towers, as seen on the left. Each of the bridge's two suspension cables were made by stringing more than 85 smaller bundles of cable, back and forth, from anchorage to anchorage. Most of these smaller strands were pulled into place by an engine with a 12-ton pull, but the very first runs had to be manually guided along by hand. For this job, temporary footbridges were erected under the future path of both cables, as seen below, and workmen exhausted themselves walking back and forth along these footbridges to guide the cables. The 4,000-foot journey began at one anchor pier, arced upward to the first suspension tower, swooped across the 1,600-foot shipping channel, and then looped back down to the opposite anchor pier. (Both, courtesy of the Maryland Transportation Authority.)

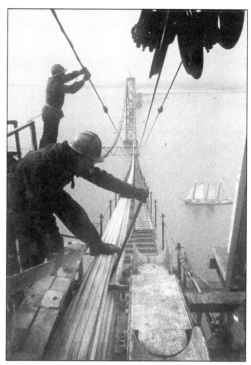

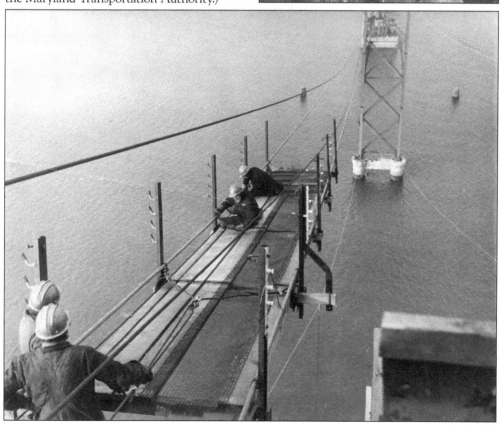

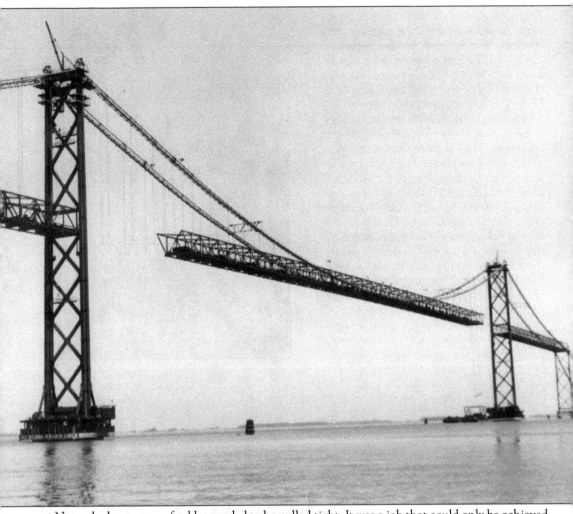

Next, the loose mass of cables needed to be pulled tight. It was a job that could only be achieved at night, for sunlight caused the top layer of strands to heat and expand, making them slightly longer than those beneath. The stable temperatures at night, however, allowed workmen to tighten the cables with uniform precision. Once taut, the smaller cable bundles were bound together in larger bundles that were then wrapped with galvanized steel wire, resulting in braided suspension cables approximately 14 inches in diameter. A protective coating of zinc chromate paste was applied to protect the suspension cables from the elements, and then, they were painted. After the two main cables were complete, the next step was to attach hanger cables that held up the deck. In this photograph, much of the roadway over the shipping channel has been hung. Note the hanger cables closest to the suspension towers are still awaiting their truss sections. (Courtesy of George Jenkins.)

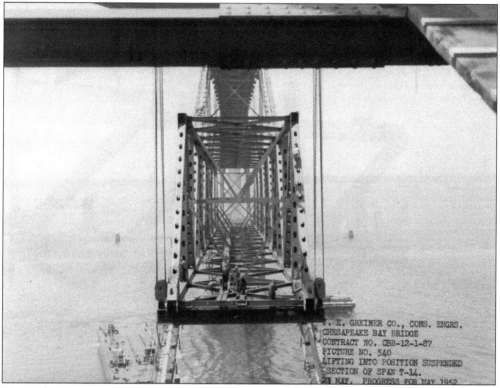

. E. GREINER CO., CONS. ENGRS.
CHESAPEAKE BAY BRIDGE
CONTRACT NO. CBB-12-1-87
PICTURE NO. 540
LIFTING INTO POSITION SUSPENDED
SECTION OF SPAN T-14.
21 MAY. PROGRESS FOR MAY 1952

These photographs offer close-up views of the suspension bridge being installed over the main shipping channel and illustrate the way the road deck literally hangs from the main suspension cables. Prefabricated truss sections weighing 50 to 125 tons apiece were craned into position from floating barges and fastened to the hanger cables, and as many as four truss sections were hoisted and hung in a single day. These hazardous operations, performed high in the air over open water, were impressive. The late Walter Woodford, an engineer for the Maryland State Highway Administration, characterized the difficulties the bridge builders faced as follows: "The construction of a bridge across the bay had a number of serious problems that had to be considered. One was the length of the bridge, which is four miles. At that time there were very few bridges that length, or even approached it. Then there were the depths of the water, the currents, the wind actions. It was not a very pleasant situation." (Both, courtesy of the Maryland Transportation Authority.)

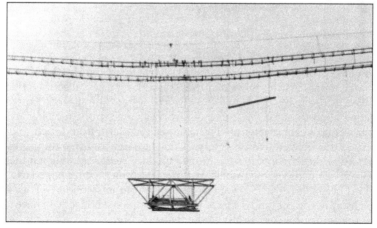

While the suspension span was being assembled, journalists from the *Baltimore Sun* paid the bridge a visit and, in this article, celebrated the steelworkers, who called the bridge "the spider web" and walked fearlessly hundreds of feet above the water. The superstructure of the bridge was held together almost entirely by rivets, and when it came to the hanging and fastening of the suspension sections, each riveter used a small work platform from which to do his job and showed bravery as they riveted trusses together. "Height doesn't mean a thing," said 54-year-old rivet foreman C.W. Leatherman. He went on to explain, "You could walk a 6-inch path across your living room floor without any trouble, but put that 6-inch path up a couple hundred feet and you wouldn't be able to do it. So, you see, it's just in your imagination." The *Sun* lauded the bridge as a "highway in the sky" and declared that the completed bridge "will have a place among the great feats of engineering." (Courtesy of the *Baltimore Sun*.)

78

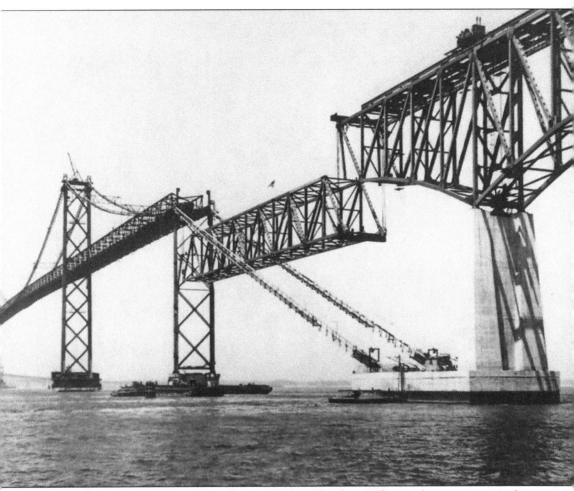

In May 1952, two months before the bridge opened to traffic, the very last steel section was raised into place just east of the main shipping channel. The truss, a deck cantilever span, was lifted nearly 180 feet from a floating barge to the elevation of the bridge's roadway. Journalist Russell W. Baker noted the momentousness of the procedure as follows: "Threading a 400-ton chunk of steel into the Chesapeake Bay Bridge as delicately as a woman threads a needle, a gang of high steel men yesterday tied together Maryland's Eastern and Western Shores with an unbroken arch four miles long. The big event happened precisely at 2:11 p.m. and moments later, when the blast of the work-barge whistle signaled the end of the job, Maryland's 30-year dream of a bay span was finally fulfilled." Also seen completed here are the suspension cables, the truss sections for the suspended roadway, and the enormous concrete anchorage pier on the east end of the suspension bridge. (Courtesy of the Maryland Transportation Authority.)

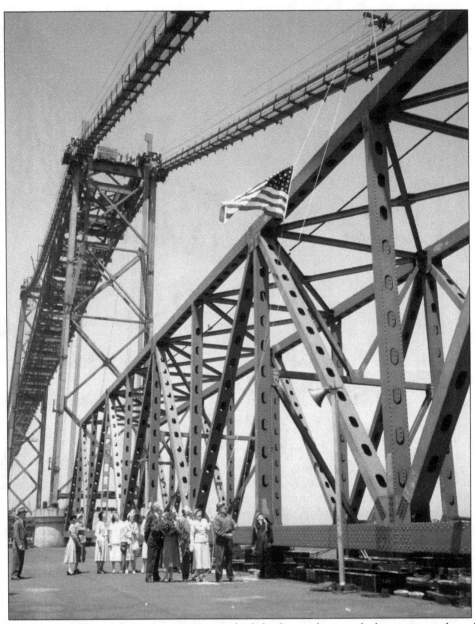

"Topping out" is the traditional ceremony in which bridge workers mark the moment when the final piece of timber, stone, or steel is hoisted into place. The custom was dutifully upheld at the Chesapeake Bay Bridge when the time came to install its last link. On May 23, 1952, the ceremonial party climbed aboard a floating barge that held the final 400-ton cantilever span for the roadway. More than a dozen men in sports jackets and ties and women wearing hats and bright spring dresses gathered near the steel section as workers lifted it and maneuvered it into place high overhead. On this occasion, Mrs. John H. Wagner, the wife of Bethlehem Steel's general manager of steel erection, the man who supervised the entirety of the bridge's steelwork, commemorated the achievement. She raised an American flag to the top of the span, proclaiming that the flag-raising and the bridge itself "symbolize peace and unity for all mankind." (Courtesy of the Hagley Museum.)

The Bay Bridge plan involved considerably more than the 4.35-mile water crossing. The total construction project, including new approach roads and east and west causeways, amounted to an overall length of 7.727 miles. This is an April 1952 view of the four-lane US Route 50, which was newly widened to accommodate the increased traffic expected from the western approach. (Courtesy of the Maryland Transportation Authority.)

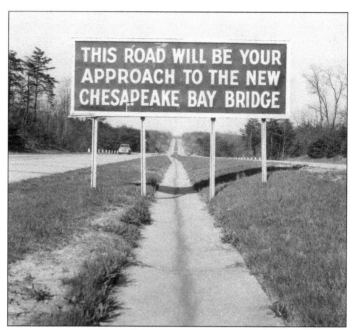

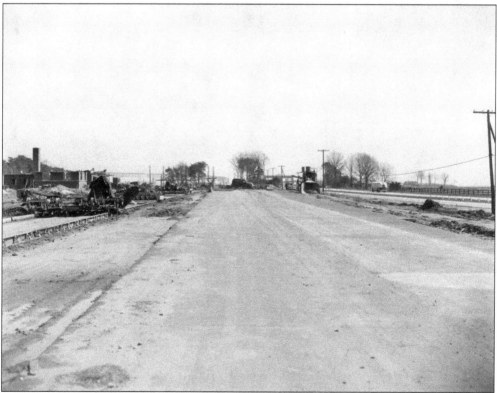

This view is of the terminus of US Route 50 at the western approach to the Bay Bridge. On the left is road-grading equipment, and the parked car in the center is approximately where the toll plaza will be erected. The plaza provided six collecting lanes, two of which were reversible to handle unusually high traffic in either direction. (Courtesy of the Maryland Transportation Authority.)

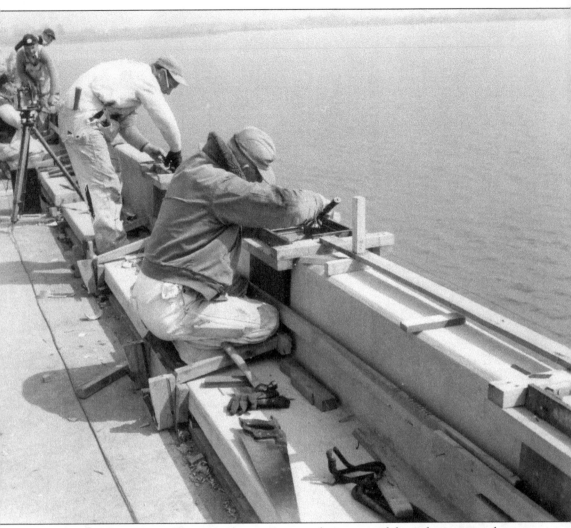

In April 1951, concrete for new bridge sections was being poured from the western abutment heading eastward. To complete the roadway, concrete men installed curbs and parapets, as seen in this photograph. The parapet sections and the barrier between roadway and a vertical drop were precast off-site, trucked to the bridge, set and aligned in grade, and fastened by the concrete workers. (Courtesy of the Maryland Transportation Authority.)

On July 17, 1952, with the bridge nearly finished, Maryland governor Theodore McKeldin paid a visit to the workmen. "It's a magnificent bridge. You don't even have the feeling you're 200 feet above the water," the governor remarked, "and the view of the bay and surrounding country is breathtaking." Over the next 13 days, workers paved the remaining roadway, installed steel guard rails, and applied another layer of paint to the bridge. (Courtesy of the *Baltimore Sun*.)

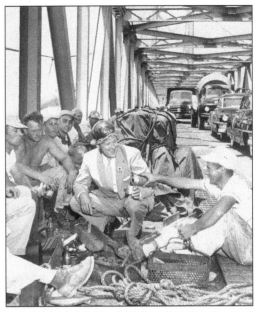

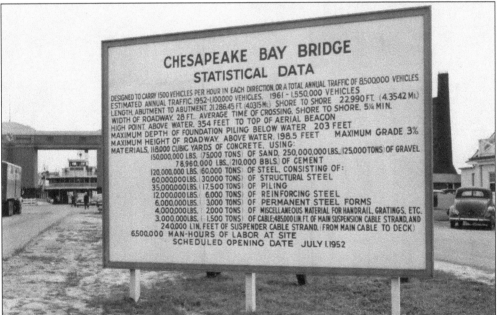

As the bridge was going up less than a mile away, Maryland highway officials had this proud message erected at the terminal of the Matapeake–Sandy Point ferry. Ferry patrons enduring the customary wait could marvel at the enormity of the bridge they would soon be using. A staggering sum of raw materials, including 118,000 cubic yards of concrete and 30,000 tons of structural steel, went into building the crossing. Three million pounds of steel strands for the two main suspension cables were employed, running a total of 485,000 linear feet. 240,000 linear feet of bundled cable to support the suspended roadbed was used. The bridge was predicted to carry 1,500 vehicles per hour, which adds up to well over eight million vehicles in a single year. By the end of the project, scores of workers had put in an estimated 6.5 million man-hours on the job. (Courtesy of the Maryland Transportation Authority.)

THE CHESAPEAKE BAY BRIDGE
Joining the Eastern and Western Shores of Maryland

From an original etching by DON SWANN

"Boats, bands and bravos will dedicate the Chesapeake Bay Bridge on July 30," read the newspaper as citizens of the Mid-Atlantic Coast anticipated the opening of the $45 million bridge. Engraved invitations went out to dignitaries, and a program book, seen here, was printed for the occasion. On its cover, the program extended the following invitation: "The Governor of Maryland, The Honorable Theodore R. McKeldin, and the members of the State Roads Commissions and the Dedication Committee request the honor of your presence at the ceremonies attending the dedication of the Chesapeake Bay Bridge on Wednesday, the thirtieth of July, Nineteen hundred and fifty two." The dedication began at 10:30 a.m. at the western end of the bridge, continued with a grand procession up and over the rising span, and concluded at the eastern end at 1:30 p.m. With the procession over, motorists would whisk across the bay in mere minutes, faster than they had ever been able to cross by ferry. The commemorative booklet had a two-page centerfold etching of the new bridge. Titled "The Chesapeake Bay Bridge: Joining the Eastern and Western Shores of Maryland," it was drawn by American fine artist Don Swann (1889–1954), who had studied art in Munich, Germany, and Rome, Italy, before calling Baltimore home. Here, he was chiefly known for his etchings of historical Americana during the first half of the 20th century. This depiction of the bridge, drawn presumably for the historic occasion of its christening, was hand-signed by the artist in pencil along the lower right margin. (Courtesy of Russ Sears.)

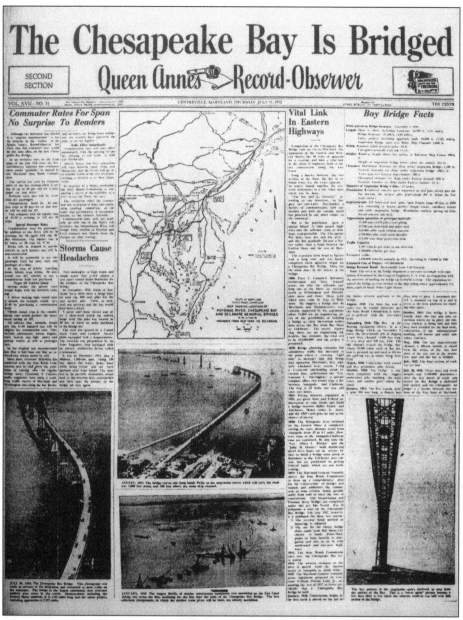

Finally, on July 30, 1952, the Eastern Shore's *Queen Anne's Record-Observer* shouted from above its masthead, "The Chesapeake Bay is bridged!" It went on to declare that the "completion of the Chesapeake Bay Bridge ends an era in Maryland—the separation of the Eastern and Western Shores" and "40 years of agitation for a crossing." More than 10,000 people crowded into Sandy Point for the kickoff ceremonies that day. During the hours-long celebration under a simmering sun, former governor William Preston Lane Jr., who championed the project despite the political risk, and current governor Theodore McKeldin, who guided it to completion, hailed the bridge as the realization of a distinctly Maryland dream. Men from all the armed services marched in review past the speaker's stand, artillery fired a 19-gun salute, and the national anthem was sung by the Baltimore & Ohio Railroad Glee Club. There was even an appearance by Francis the Talking Mule, the famous Hollywood quadruped. (Courtesy of the Chesapeake Bay Maritime Museum.)

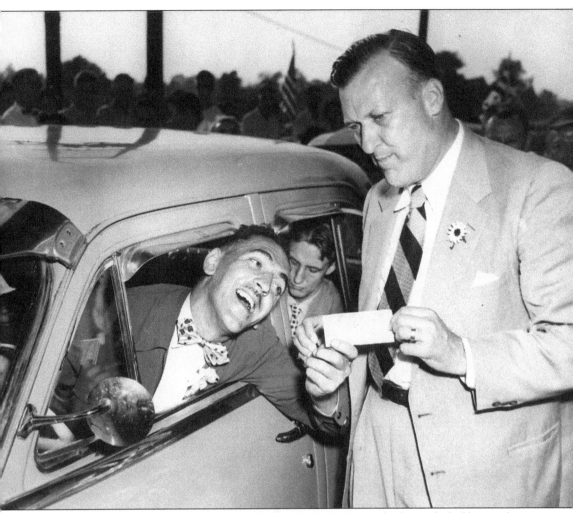

Adding to the flamboyance of the day was "Mr. First," who had waited a day and a half just to be the first toll-paying customer to speed over the bay. Omero C. Catan, a resident of Long Island, New York, and a Yankee Stadium caterer by trade, found his passion in claiming over 400 firsts, from the first New York marriage license issued in 1939, when he wed Mrs. Catan, to first across scores of new bridges that had been built in Florida. Although there were a handful of people who crossed unofficially the day before, Mr. First asserted that the real first driver over a toll bridge would have to be the first person to pay the toll and cross. After 36 hours parked first in line at the toll plaza, eating meals in the front seat of his car and shaving by the roadside, with his front fenders decked with American flags and the words "Mr. First" painted on the windshield, Omero Catan's dedication paid off. The photograph above captures his official recognition by Gov. Theodore McKeldin as the first toll-payer on the Bay Bridge. (Courtesy of the Chesapeake Bay Maritime Museum.)

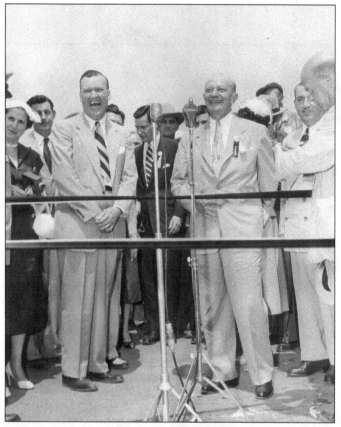

After Governor McKeldin and former governor Lane snipped the ceremonial ribbon, performing the honors seen here, the third-largest bridge in the world was ready for service. As the cars began to roll over the new span, each motorist was saved 125 miles over the old route up and around the bay at Elkton, Maryland. (Courtesy of the Maryland State Archives.)

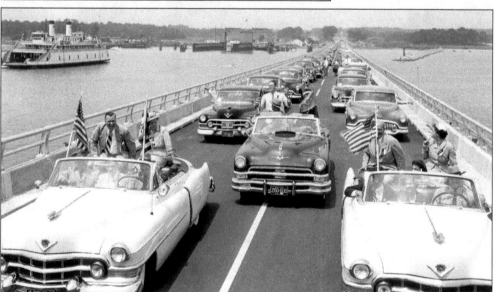

Governors McKeldin and Lane led the rest of the dignitaries in a motorcade across the bridge from west to east. At least 2,300 cars crossed the Bay Bridge in the first six hours of operation, and a total of 8,274 vehicles used the bridge in the first 24 hours, for an average of about 350 cars per hour. (Courtesy of the *Baltimore Sun*.)

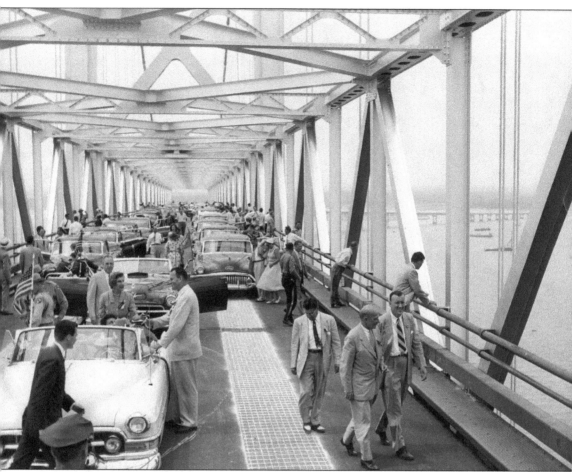

The opening parade of celebrants took more than two hours to cross the 4.35-mile span. Spectators, including Governors Lane and McKeldin, got out of their cars to inspect the structure and marvel at the panorama. Revelers made wishes and threw coins over the railing. Everyone took in the Chesapeake Bay from the 183.5-foot-high vantage point that had not previously existed. They also felt, disconcertingly, the suspension section swaying ever so minutely underfoot, and they watched as two ferries made their final crossings in the shadow of the span before they docked one last time and were taken out of service. Slow as the motorcade high above the Chesapeake Bay may have been that day, Maryland's transportation future was exceedingly bright. Thanks to the triumph of bridge construction, residents of the Eastern Shore could now speed easily to the big city of Baltimore, while Western Shore citizens could make the drive to Ocean City in record time. (Courtesy of the Chesapeake Bay Maritime Museum.)

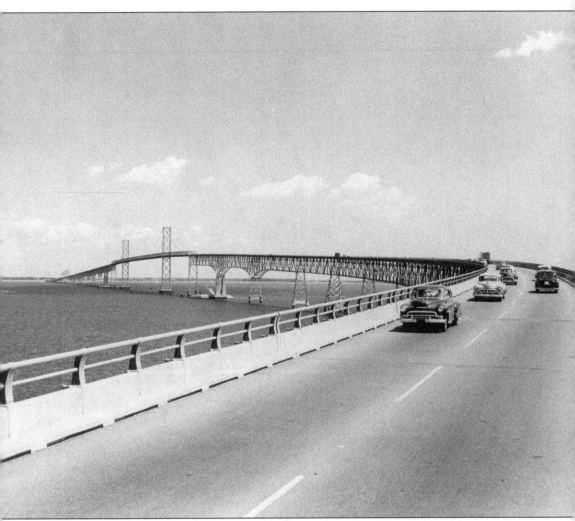

Automobiles began streaming over the two-lane east-west link at the permissible speed limit of 40 miles per hour, crossing in six minutes what once required 22 to 25 minutes on the old ferries, along with significant waiting and loading times. Almost immediately, the new bridge handled three times the business of the ferries, nearly 30,000 cars in the first three days alone, and many of them tourists eager to see the new attraction. The ferries that had operated between the two shores for 33 years ended their careers by carrying cars and passengers free of charge, per Gov. Theodore McKeldin's instructions. In a ceremonial gesture, two ferries left Sandy Point in the east and Matapeake in the west at the same time. They met in mid-bay, saluted each other, and officially went out of service. Even after the launch of the new bridge, a few finishing touches remained to be completed. During the opening months of operation, the bridge still had workers dangling from wires while applying four additional coats of paint to the steel superstructure. (Courtesy of the Enoch Pratt Library.)

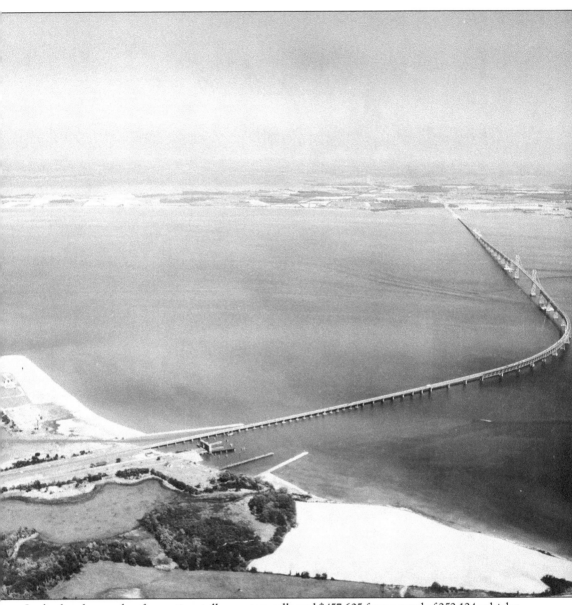

In the first four weeks of operation, toll operators collected $457,605 from a total of 252,124 vehicles crossing the bridge. This was an average of slightly more than 9,000 vehicles a day—almost three times the traffic flow engineers had estimated before the bridge was built. It was clear that the bridge would have no trouble paying off the revenue bonds that were taken out to build it. On the other hand, Nancy Altoff, who worked as a toll taker in those early days of operation, recalls that she was not always paid in cash: "Back in the day, if a customer didn't have enough money, they were allowed to leave a tool, a tire, a watch or a ring" as collateral against an unpaid toll. The quaint habit ceased when the toll facility became inundated with forsaken possessions. Expressing special fondness for the job, Altoff said, "I remember a farmer who would give us a couple dozen brown eggs, a basket of tomatoes, or he'd say, 'Hey, want a cantaloupe?' You don't see that kind of stuff anymore." (Courtesy of the Kent Island Historical Society.)

VOL. XLV, No. 9
10¢ THE COPY

JULY, 1952

PUBLISHED MID-MONTHLY BY THE BALTIMORE ASSOCIATION OF COMMERCE

Merchants in Baltimore eagerly advertised the benefits of the new bridge. For 30¢, Marylanders could buy this July 1952 issue of *Baltimore* magazine, a publication of the Baltimore Association of Commerce, and peruse photographs and articles commemorating the state's great achievement. In a subtle yet calculated marketing ploy, the bridge is depicted on the cover sweeping elegantly to the horizon and suggesting the new roadway will lead to prosperity. Business leaders on the west hoped the new bridge would bring a surge of agriculture and seafood, while those on the east anticipated an influx of manufactured goods. The bridge would carry Eastern Shore shoppers over to the department stores, restaurants, and movie houses of the big city. Baltimore mayor Thomas D'Alesandro Jr. issued the following enticement: "Now ever so much closer to all parts of the 'Shore, Baltimore offers many attractions to our fellow Marylanders across the Bay . . . Shopping will be a convenient pleasure. So, to the people of the Eastern Shore, Welcome to Baltimore! The Key to the City is yours!" (Courtesy of the Maryland Transportation Authority.)

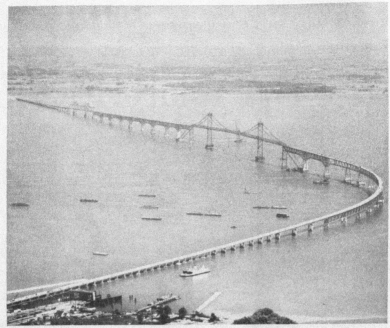

The July 1952 issue of *Baltimore* magazine was a cover-to-cover salute to the Bay Bridge, with advertisements for many of the businesses that helped construct it. Here, Bethlehem Steel proclaims something that could not have been said before: "Steel spans the Chesapeake." The company reminded readers that it fabricated the steel superstructure of the bridge and erected the steel cables. It praised the bridge as "one of the greatest structures ever built" and "the fulfillment of a dream cherished for many years." Bethlehem Steel also saw the following future in which the two sides of Maryland would unite in a new, more symbiotic relationship: "Vacationists will now drive quickly from their homes on the mainland to recreation spots on the Eastern Shore, while farmers and fishermen on the Del-Mar-Va peninsula will send their products across the span to markets in Baltimore and Washington." (Courtesy of the Maryland Transportation Authority.)

In this advertisement, the Retail Merchants Association of Baltimore rolled out the red carpet to shoppers across the Chesapeake Bay. They characterized the new bridge as a metaphorical magic carpet that would bring their neighbors from the Eastern Shore. "The stores alone are worth a trip to Baltimore!" it gushed. The Baltimore merchants also noted that the state of Maryland, once divided, was now solidly united by the new bridge: "The majestic four-mile-long Chesapeake Bay Bridge becomes a bond that draws two vital parts of Maryland together." Manufacturers and shopkeepers on the Western Shore were clearly awaiting the happy upswing in business they believed to be just around the bend. (Courtesy of the Maryland Transportation Authority.)

94

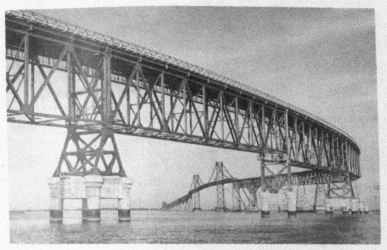

The Davidson Transfer and Storage Company, a Maryland-based moving outfit, placed this advertisement honoring the new bridge as "a tangible symbol of Maryland's progress towards a modern highway system." Davidson saw the bay span as a "prelude to prosperity" and "a new era in road modernization" that would "serve as a model for the nation . . . contributing to the prosperity of our state, adding to the strength of our country." The bridge so inspired this trucking company that it decided to include the following reflections of R.H. Grenville, a poet who appears to have been lost to history, but whose words, when uttered in reference to Maryland's greatest public works engineering project, elevated the achievement to even loftier heights: "A bridge is an emphatic affirmation / It is man's way of answering, 'I can!' / To Nature's 'You Cannot!' / There is no limit to what can be done. / By those who, long ago, acquired the habit, / Of fashioning a way where there was none." (Courtesy of the Maryland Transportation Authority.)

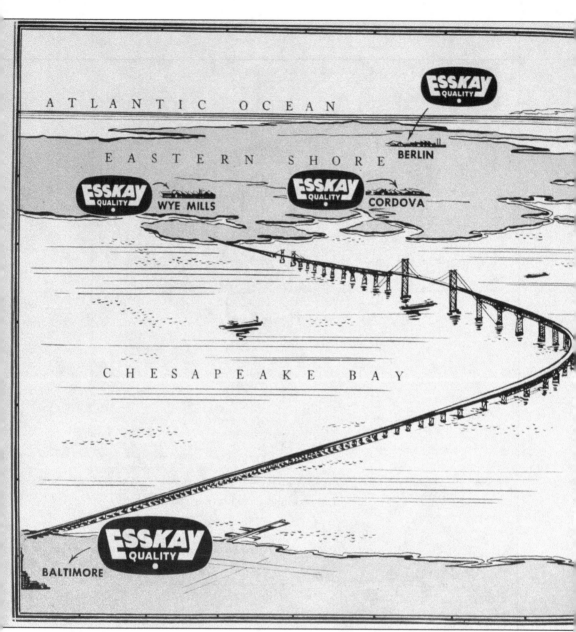

Although Esskay Meat Products, the hot dog and lunch meat brand founded in Baltimore by German immigrants, had nothing to do with the building of the Bay Bridge, its advertisement "salutes the gleaming new Chesapeake Bay Bridge, whose steel girded highway now enables you to journey between Baltimore and the Eastern Shore in a matter of minutes." For good reason, Esskay was "particularly gratified by this magnificent achievement." The bridge brought their Eastern Shore livestock-buying station at Wye Mills, Maryland, and its poultry plants at Cordova and Berlin, Maryland, much closer to home. The benefit the company derived from the bridge was twofold: the raw materials coming over to its Baltimore processing plant and its finished processed meats could both reach their destinations quicker and cheaper than before, which increased the products' shelf life. (Courtesy of the Maryland Transportation Authority.)

AN INVITATION
to a
GRAND VACATION

DANIEL TRIMPER, JR.

TO OUR NEIGHBORS:

There are more than 4,000,000 of us living within 300 miles of Ocean City; in Maryland, the District of Columbia, Delaware and the lower portion of Pennsylvania. We are all neighbors and have much in common as all good neighbors do.

Perhaps, however, we do not know each other and each other's towns as well we might.

Now that the Chesapeake Bay Bridge has become a reality, you are no longer dependent on the State Ferry system with its 30-minute crossing time to come from the Western to the Eastern Shore. Via the Bridge, the crossing can now be made in just 10 minutes.

Most important however, is the time conserved over busy weekends and holidays by the elimination of the vexatious waits at both ends of the old Ferry terminals.

It is a genuine pleasure to extend a personal invitation to come to Ocean City, Maryland's Playground, as often as possible.

On the other hand, as Mayor of Ocean City, I urge all Ocean City residents to visit our neighboring communities frequently, to the end that through better acquaintanceship, we will come to understand our mutual problems better.

Sincerely yours,

DANIEL TRIMPER, JR.,

Mayor

Among the many beneficiaries of the new bridge were the hoteliers, shopkeepers, restaurateurs, and amusement operators in the beach town of Ocean City. Even while the bridge was going up, the town was preparing to receive the anticipated throngs of vacationers. With such opportunity on the way, Ocean City mayor Daniel Trimper Jr. extended the "invitation to a grand vacation," seen here, laying out the arguments for a visit to the seaside resort. "Now that the Chesapeake Bay Bridge has become a reality," he reasoned, "you are no longer dependent on the State Ferry system with its 30-minute crossing time to come from the Western to the Eastern Shore." Closing the sales pitch, he said, "Most important however, is the time conserved over busy weekends by the elimination of the vexatious waits at both ends of the old Ferry terminals." Trimper knew that the ease with which vacationers would be able to reach the beach was his greatest selling point. (Courtesy of the Maryland Transportation Authority.)

Two great brews...
ONE'S for *YOU!*

Both Lighter...
Both Drier...
More Satisfying!

"BOH" IS BOHEMIAN—You get real *Bohemian* flavor at its brilliant best in "Boh" —National Bohemian. Oh boy, *what* a beer!

PREMIUM IS PILSENER—Prefer Pilsener? Then you'll be pals with National Premium. It's mellow...delicate. It's the *true* Pilsener!

NATIONAL BOHEMIAN

"Oh boy—what a Beer"

NATIONAL PREMIUM

"The TRUE Pilsener"

What's Your Choice?

The National Brewing Company
Baltimore 24, Maryland **ORDER YOUR FAVORITE—TODAY!**

By the time readers had waded through the July 1952 issue of *Baltimore* magazine, with its 70 pages of back-slapping, they were rewarded with one final tribute from the National Brewing Company. This advertisement amounted to a full-page toast to a job well-done. There was the cadre of bridge believers who could rightly take credit, like the persistent politicians who battled financiers, critics, and grumblers and saw it through; the engineers and planners who made the impossible possible; and the workers—surveyors, crane operators, divers, steelworkers, riveters and rivet punks, cable runners, inspectors, electricians, barge pilots, concrete puddlers, and countless others—who constructed the bridge in record time. The two beer mascots, both the mustachioed man in tuxedo and the monocle-clad figure in lederhosen, were surely blowing their horns not only to sell their respective brews, but also to toast the toil and achievement of the thousands of people who built the bridge. (Courtesy of the Maryland Transportation Authority.)

Five

TRANSFORMING CHESAPEAKE COUNTRY

Even before the first pile was driven below the bay, a writer for the *Baltimore Sun* summed up what most Marylanders already knew—the double-edged sword of change was coming to Chesapeake Country:

> The Eastern Shore is chiefly an agricultural community, and there are advantages to the farmer in getting his produce quickly to market. The bridge, therefore, should serve as a fresh stimulus to production. Possibly, too, the new proximity to the city's supply of labor might result in an increase in industry on the Shore. There is certain also to be a growth in the use of respective recreational facilities of the Shore on the one hand and of the city on the other. Whatever else it does, the bridge will bring about a change in local scenes, habits and ways of thinking. This will be deplored by those who like things as they are. Yet, despite this loss, we can believe that the new meeting of East and West will be largely profitable to both.

When at last 60,000 tons of steel "clasped hands across the broad Chesapeake Bay," an impressive new landmark glittered brightly on the Maryland landscape. And while the bridge fulfilled the dreams of many residents by making the state of Maryland whole, the saga of the bridge is also about the forces of change and of how private citizens had to make way for the public good. The bridge was emblematic of the unrelenting push for progress that swept across most of post–World War II America. In 1950, well before the grand opening, the Maryland Planning Commission released optimistic economic predictions for the Chesapeake Bay Bridge, speculating that it would bring as many as 450,000 more vacationers to the Eastern Shore in the first year of its operation. The tourists would save nearly an hour in travel time over the old ferry routes and cause increases in revenue valued in the tens of millions of dollars.

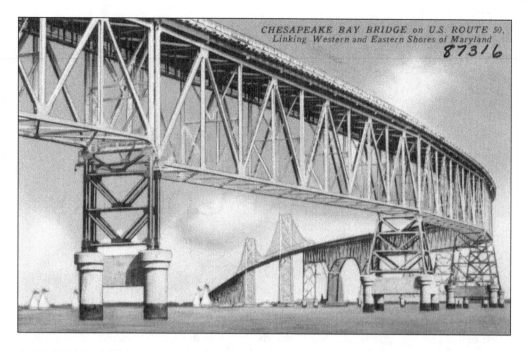

CHESAPEAKE BAY BRIDGE on U.S. ROUTE 50, Linking Western and Eastern Shores of Maryland

As soon as the bridge went up, Marylanders crossed the Bay Bridge with ease, speeding over the water by the tens of thousands. In 1953, its first calendar year of operation, the bridge was traversed by nearly two million vehicles. Indeed, it became a destination all its own, attracting curious tourists eager for the exhilarating driving experience. This postcard is one of many that the Harry P. Cann & Brother Company of Baltimore, Maryland, sold to both bridge admirers and those who had crossed its summit and wished to share the feat with loved ones back home. The back of the postcard boasts of the bridge's impressive length and height: "This marvelous engineering feat links Maryland's Eastern and Western Shores. Its length of 4.35 miles makes this one of the longest bridges in the world . . . At its highest point, the roadway is 198.5 feet above the Chesapeake Bay." The sender of this postcard dryly acknowledged the bridge's imposing height as follows: "Hello Mother, this is some bridge—sure would hate to fall [off] it." (Both, courtesy of the Boston Public Library.)

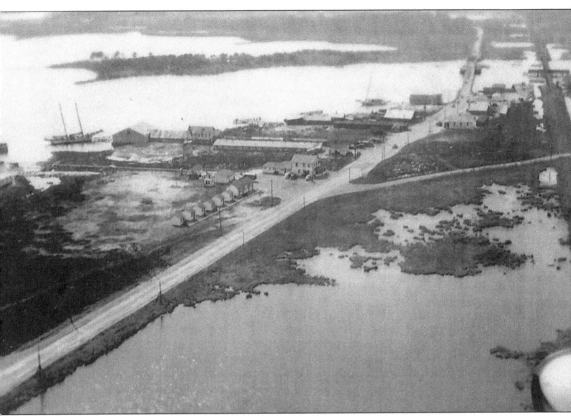

A traveler who crossed over the bridge from Sandy Point landed on Kent Island at the eastern terminus of the Bay Bridge. It was a small rustic community with an economy based largely on seafood harvesting. This photograph shows the fishermen's cabins, skipjacks, and crab-picking houses of Grasonville, Maryland, located adjacent to the road and railroad bridges over Kent Narrows. When the photograph was taken, rural electrification had recently been completed; housewives had adopted electric ranges and refrigerators, dairy farmers employed electric milkers, and the island boasted roughly 18 television sets. Locals were understandably fearful of less favorable changes, including the state's plans to cut a superhighway through the area. As one citizen wrote, the new bridge was "likely to produce shudders in those who know and love the shore's present open spaces and unspoiled roadsides. Hordes of tourists, vacationers and out-for-the-day motorists do not bring blessings for the landscape. They bring hot dog stands, taverns, billboards, night spots, bar-b-q's, tourist cabins, automobile graveyards, gasoline filling stations, gambling joints." (Courtesy of the Kent Island Heritage Society.)

The Bay Bridge project included the widening of 3.37 miles of approach roads at each end of the crossing. Pictured here is the new four-lane US Route 50 outside of Annapolis, Maryland, that led motorists to the bridge at Sandy Point on the Western Shore. As increasingly heavy traffic motored over the bridge and along the unimproved rural roads approaching it, countless miles of roadway were widened over time. (Courtesy of the Maryland Transportation Authority.)

In 1952, Kent Island resident Jeannette Elizabeth Nash was notified by Maryland road officials that a new highway, shown at the left, would bisect her Kent Island farm. Poor and ill-equipped to fight, Nash stayed on until the concrete trucks had literally paved the road that divided her farm. At that point, after the cement had dried, she finally left her farm. (Courtesy of the Maryland Transportation Authority.)

Along with the bridge and newly improved highways, hordes of vacationers came to the Eastern Shore, advertised as "the land of pleasant living." The inrush created new business opportunities that local entrepreneurs quickly seized. Lodgings, like the Bay Bridge Motel in Grasonville, Maryland, seen in this postcard, popped up along US Route 50 and other Delmarva highways to accommodate the stream of travelers. (Courtesy of the Boston Public Library.)

The Eastern Shore had long been seen as a place of rest and relaxation. It was also a sportsman's paradise, with abundant forests for hunters and an endless shoreline for anglers. This postcard shows the Chesapeake Motel in Grasonville, Maryland, which enticed excursionists not only with "excellent fishing, boating & hunting" but also a "TV in every room." (Courtesy of the Boston Public Library.)

Ocean City, Maryland, was an important factor in building the bridge—the Eastern Shore beach resorts needed better access to their customers across the bay. Thanks to the new bridge, getting down to the ocean, or "downee ocean," as Marylanders liked to say, to the sand, surf, and sea breezes of Ocean City was never easier, and vacationers arrived there in record time. Former Ocean City mayor Roland "Fish" Powell recalled, "If there was ever a single thing to put your finger on to make Ocean City prosper and grow, it was the Bay Bridge. It was like night and day. It made all the difference in the world." While the completion of the bridge was a watershed moment for Maryland, it was also utterly transformational for the tourist industry along the entire Mid-Atlantic Coast. The barrier of the Chesapeake Bay, which, for so long, had inhibited vacationers from venturing to the shore, had finally been traversed. (Courtesy of the Boston Public Library.)

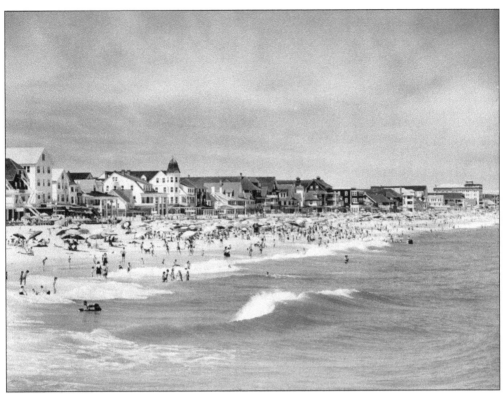

The photograph above is a view of Ocean City's beach, and the photograph at right is of sunbathers who frolicked on the beach after the bridge was built. Thanks to the Chesapeake Bay Bridge, the isolated, sleepy fishing village era of Ocean City was over. Ever since the hurricane of 1933 roared through, cut an inlet into the sand, and made Ocean City an important fishing port with a safe harbor, its popularity grew. Each summer prior to 1952, the seaside playground, with four-mile-wide white sand beaches, had drawn thousands of beachgoers from Baltimore, Washington, DC, and other areas along the East Coast. With the Bay Bridge, the number of summer visitors skyrocketed. The spike in tourism precipitated a rapid expansion over the following decades and transformed Ocean City into one of the largest vacation areas in the eastern United States. (Both, courtesy of Aubrey Bodine.)

Ocean City's lifeguard crews, seen here, were ill-prepared for the impact of the Bay Bridge. Jared "Lucky" Jordan, pictured at right, remembers early August 1952 in particular, the first weekend after the inauguration of the bridge, when blustery weather turned their routine jobs into a frantic rescue mission: "We were briefed by Captain Bob Craig that the Bay Bridge was opening up, and by Friday afternoon we saw more people on the beach than we'd ever seen before, and by Saturday morning it was wall-to-wall. And Old Man Ocean just seemed to know. We had high winds off the ocean, huge waves breaking 75 yards out, and riptides running all along the beach." Referring to the many swimmers who required rescuing, he recalled, "I can't tell you how many 'pulls' I made, but it was a lot. Every guard on the beach had to pull one after another. I mean, I was in and out of the water all weekend. It's the busiest a time as I've ever known." (Both, courtesy of Lucky Jordan.)

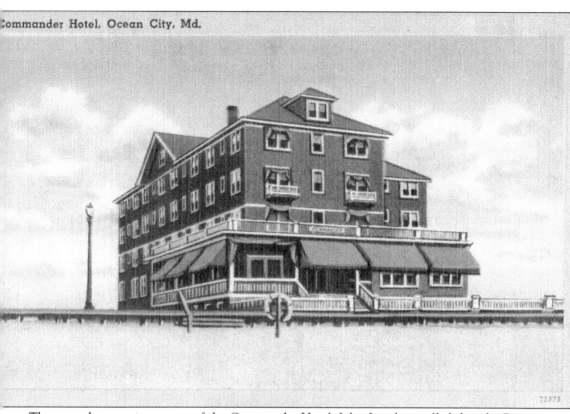

The second-generation owner of the Commander Hotel, John Lynch, recalled that the Bay Bridge "really opened up the Eastern Shore. In the old days people would come down and stay 10 days, two weeks, some people even spent a month with us because getting here was a chore. Now they come down and enjoy themselves and don't feel like they've spent the whole vacation in a car getting here." The Commander, seen in this postcard, was a harbinger of the changes in real estate that came to Ocean City after the bridge opening. In 1930, when the Ocean City boardwalk ended at Third Street, Lynch's father built his hotel way to the north in the sparsely populated area at Fourteenth Street, a location considered so far out of town that locals snickered that he would never live long enough to pay off the mortgage. The opening of the Bay Bridge two decades later launched relentless beachfront development that marched up the Atlantic Coast and surrounded the Commander Hotel. (Courtesy of John Lynch.)

In the years prior to European contact, indigenous people harvested seafood from the Chesapeake Bay, the nation's largest estuary. In 1614, Capt. John Smith explored the Chesapeake and claimed it was so gorged with rockfish that one could walk across the water on their backs. More than 300 years later, the bay had a new spot to fish. Perhaps an unplanned consequence of the bridge was its success as a productive fishing hole that drew recreational anglers to try their luck below it. The theory was that the bridge acted as an artificial reef, attracting small bait fish to feed on its rock islands, piers, and pilings, which in turn enticed large numbers of sport fish, like perch, trout, bluefish, and striped bass. Those in turn attracted the anglers, seen here, who sought to catch them. The photographer of this image titled it "Day on the Bay," capturing three fishing buddies plying a spot near the bridge in the hope of landing a lunker striped bass, Maryland's state fish. (Courtesy of Aubrey Bodine.)

In this image, taken by photographer Aubrey Bodine, the ancient Chesapeake tradition of oystering is juxtaposed with the modern backdrop of the handsome new bridge. Renowned Chesapeake oysters were the cash crop of the bay for much of Maryland history, and harvesting them was profitable work for the state's watermen. In this photograph, a two-person crew is harvesting oysters using hand tongs, a manual method in which the tonger extended a long-handled, two-sided rake to the bottom and scraped through the mud while closing the jaws of the rake. The tonger caught oysters in this crude claw, hauled them up, and dumped the load onto a makeshift sorting table on the boat. The culler then separated the catch into keepers, which he threw into a bushel basket, and the immature mollusks, which he cast overboard to continue growing. This process continued until the harvest limit was reached; next, the watermen hauled the catch to the buy boats, seafood markets, and shucking and canning operations all around the bay. (Courtesy of Aubrey Bodine.)

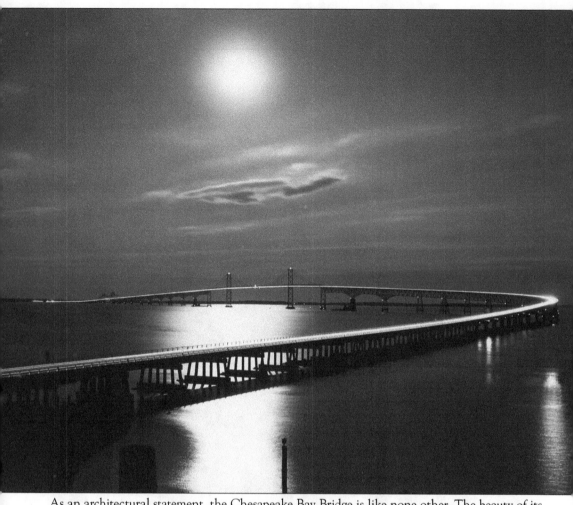

As an architectural statement, the Chesapeake Bay Bridge is like none other. The beauty of its gentle rise and sloping curve inspired the making of this moonlit image by photographer Marion E. Warren in 1953. The story goes that, to capture the photograph, Warren waited a year for the clouds, lighting, and winds to be just right. Eastern Shore historian and sailor Pete Lesher saw similar beauty in the bridge. He said, "The slenderness of that bridge, as compared to its length and its height, really makes it quite a beautiful sight. There's something about suspension bridges, a majesty to the height of the towers and the arc of the suspension cables." And while some people were fearful of the new crossing, Celia McGrain, whose grandfather Herschel Allen helped build the bridge for the J.E. Greiner Company, was awestruck by it: "I don't think I will ever tire of driving over that bridge. There's always an excitement." To ensure the fullest possible experience when crossing it, McGrain has a strategy: "I roll down my windows, every time, no matter if it's winter or summer." (Courtesy of Marion Warren.)

Six

A Second Span

On the first Sunday of operation, the surge of vacationers heading home from the Eastern Shore was too much for Maryland's new $45 million bridge. A Baltimore newspaper ran the headline, "Bay Bridge Tourists Run Into Traffic Jam," and the accompanying photograph showed the traveling public loitering alongside their vehicles, waiting for the line to move. "So this is the Bay Bridge?" they asked as cars were stacked up as far as the eye could see. The jam resulted from the cumulative effects of three cars that ran out of gas, four flat tires, and dawdling tourists who slowed down to take photographs and, as the reporter observed, "did too much sightseeing." From the beginning, congestion at the bridge—especially during summer weekends—was commonplace. Although four long decades had transpired from the first discussions of a Chesapeake crossing to its inauguration, it was only a few short years after the bridge opened that talk began of the need for a second span. The populations in Baltimore, Maryland, and Washington, DC, had grown throughout the 1950s and 1960s, and real estate development on the Eastern Shore was booming. Travel over the Bay Bridge was on the increase, and the problem of expediting vehicles across the bay resurfaced. Before the first span was ever built, engineers estimated it would carry some 3,295 vehicles per day during its initial year of operation; on that first crowded Sunday, an estimated 15,880 cars and trucks used the span. The bridge had been deemed inadequate as early as 1959, when Maryland chief of roads commission John B. Funk said, "It's my guess that by 1962–1963 some decision will have to be made on whether or not to build another bay crossing." In 1964, the state turned once again to the J.E. Greiner Company and tasked them with studying the possible locations for a second Bay Bridge. In 1967, the legislature authorized the new crossing, and in 1969, workers broke ground for a new span to be erected alongside the original bridge. The cost of the project was estimated at $73 million.

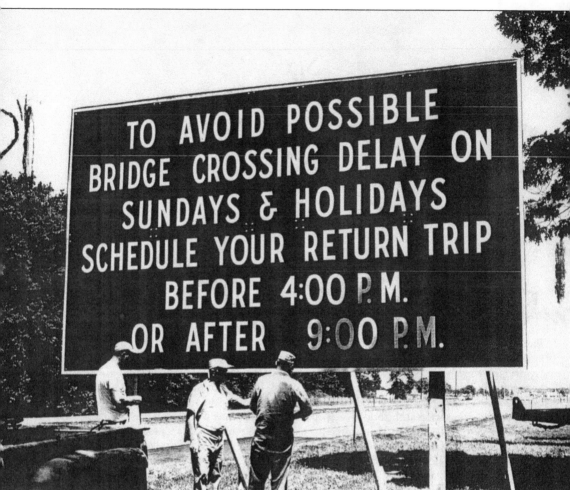

It was not long before the traffic capacity of the original Bay Bridge, at least during peak travel hours, had reached its limits. On August 13, 1961, a record 23,000 cars clogged the bridge's two narrow lanes, and two weeks later, the Bay Bridge recorded its 30 millionth vehicle crossing. In their first nine years of collecting, toll takers had received $47.5 million in revenue, roughly enough to pay back the bonds issued in 1949 to build the bridge. In 1964, in an attempt to ease the traffic crunch, the workers seen here erected a sign along US Route 50 that encouraged motorists to travel at off-peak times. The hope was that by shifting traffic volume to nonpeak hours, the chronic weekend congestion might be at least partially alleviated. But by then, it was already clear that a more permanent solution was necessary. Public sentiment for another Chesapeake Bay crossing had become stronger, and Maryland governor J. Millard Tawes was fully committed to a new Bay Bridge somewhere over the Chesapeake. (Courtesy of *News American*.)

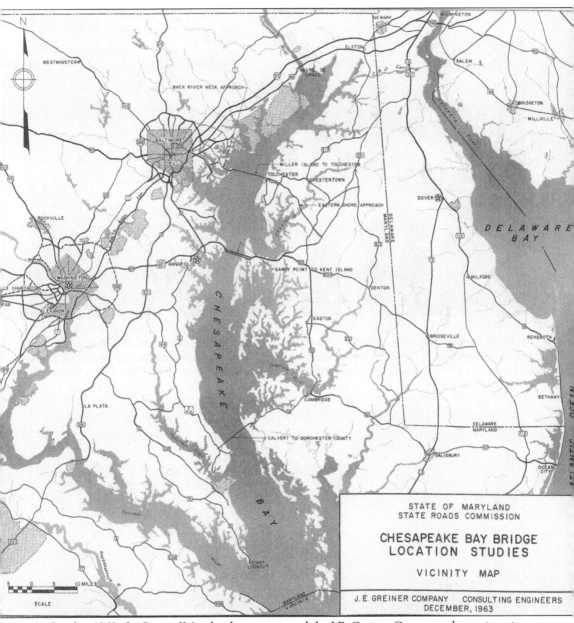

STATE OF MARYLAND
STATE ROADS COMMISSION

CHESAPEAKE BAY BRIDGE
LOCATION STUDIES

VICINITY MAP

J.E. GREINER COMPANY CONSULTING ENGINEERS
DECEMBER, 1963

In October 1963, the State of Maryland commissioned the J.E. Greiner Company, the engineering firm that had designed the first bay span, to study possible locations for another bridge. Maryland tasked the company to analyze the following three locations: a northern bridge running from Miller Island to Tolchester, another following the existing bridge from Sandy Point to Kent Island, and a southern crossing from Calvert County to Dorcester County. Baltimoreans naturally favored the closer northern bay option, while politicians in the lower Eastern Shore favored the southern route, but it was the Greiner cost estimates—$73 million for a parallel bridge, $165 million for a northern span, and $119 million for a southern span—that led Governor Tawes to back the far more economically feasible parallel span. On May 28, 1968, the US Coast Guard authorized the construction of just such a bridge—what many now call the Parallel Span—to be located 450 feet to the north of the first Chesapeake Bay Bridge. (Courtesy of the Enoch Pratt Library.)

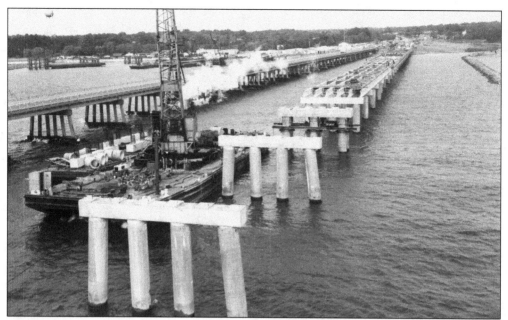

Work on the second Bay Bridge began on May 19, 1969. Once again, pile drivers sank various types of foundations into the bay's bottom to hold up a four-mile-long roadway. The pile bents in the foreground of this photograph were driven at different angles to account for transverse loads like wind, water flow, dead load, and traffic. Such a technique gave the piles stability. (Courtesy of the J.E. Greiner Company.)

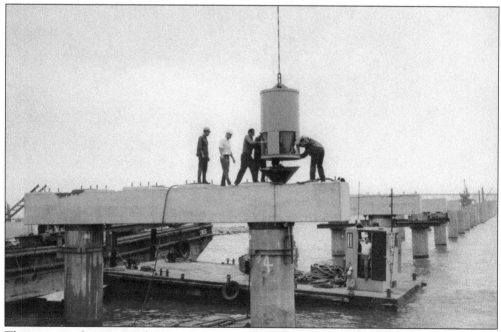

The men seen here are working atop concrete beams called bent caps. These horizontal beams were installed on top of the piles to tie them together so that the weight of the roadway was distributed evenly to each pile. In this photograph, workers are pouring concrete cap plugs into the beam at Pier No. 4. (Courtesy of the J.E. Greiner Company.)

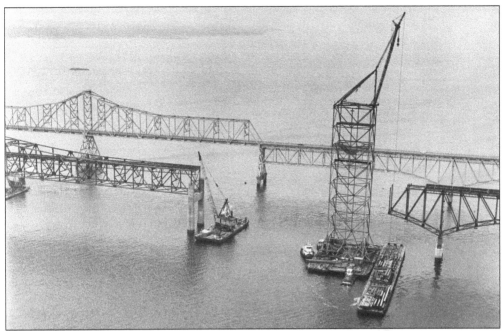

The design of the new bridge, thus the construction methods employed, closely resembled the original bridge. The superstructure was built of a variety of bridge types—through cantilevers, deck cantilevers, truss cantilevers, and a 1,600-foot-wide suspension section over the Baltimore shipping channel—all strung across the water. This towering crane is hoisting the east cantilever sections from the supply barge up to their installation points. (Courtesy of the J.E. Greiner Company.)

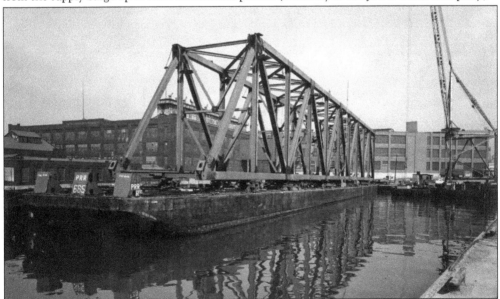

Steel trusses were fabricated by the US Steel Corporation and floated by barge to the construction site. This through cantilever section of the bridge, identified as Span No. 45, is seen on March 1, 1972, as it waited in the port of Baltimore, Maryland, before it was towed the roughly 30 nautical miles south to the construction site, where it was hoisted into place. (Courtesy of the J.E. Greiner Company.)

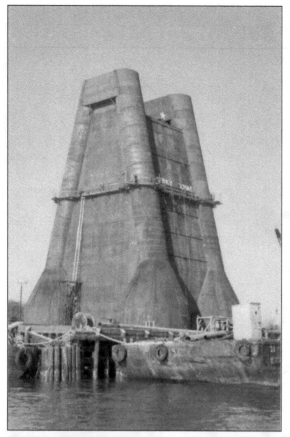

On the left is a giant metal form used to make a Potomac pier, seen here before it was lowered to the bottom of the bay for the bridge's foundation. Because of its immense size, this form was likely used for one of the suspension span piers. The bell-shaped can was placed on the bay floor and filled with concrete using the tremie cement-pouring method; the procedure involved feeding cement by gravity from a hopper on the surface of the bay down through a tube into the submerged form. As concrete gradually filled the form, water was displaced out the top, and when the concrete hardened, a solid mass within formed a suitable pier. According to the bridge plans, there were 12 Potomac piers built using this kind of four-bell form, while the remaining Potomac piers were made using similar but smaller two-bell versions. (Both, courtesy of the J.E. Greiner Company.)

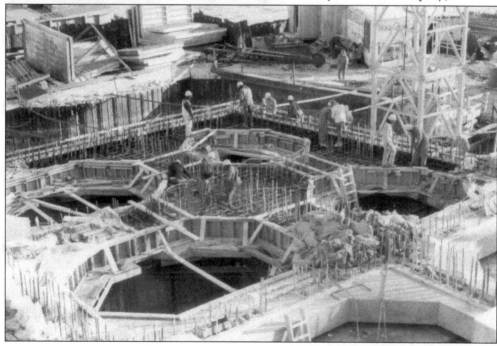

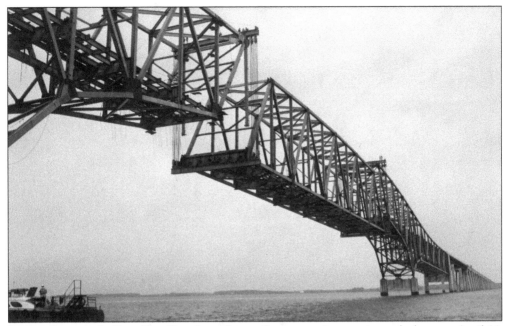

In this photograph, Span No. 45, a through cantilever truss, is seen six weeks later on April 14, 1972. It had been floated down the bay and was in the process of being lifted into place using a typical bridge lift. Steelworkers installed this truss near the western end of the bridge, and this section of bridge was designed to carry the road over a secondary shipping channel. (Courtesy of the J.E. Greiner Company.)

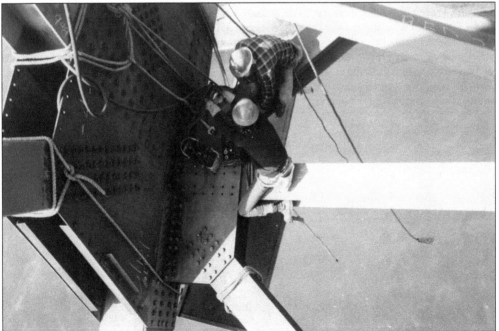

Unlike the original span with its trusses that were hot-riveted together, the steelwork of the sister span was fastened together using bolts. After Span No. 45 was hoisted, the workers seen here bolted the truss into place at a lofty height. (Courtesy of the J.E. Greiner Company.)

An impressive method was employed to pour cement for the twin 20-story anchorage piers for the bridge's suspension cables. A Sikorsky Skychief helicopter, known as a sky crane, filled its bucket from a concrete plant floating on a barge nearby. With a full hopper that carried eight tons of concrete per batch, it flew high over the anchorage, gently dropped in altitude, and opened the hopper's jaws at the right moment to drop its heavy wet load. The helicopter pouring method had a number of advantages over barge-borne concrete hoisting, pumping, and chuting methods. While the sky crane was the costliest piece of equipment used on the project, it significantly shortened concrete transit times, simplified its distribution by reducing the need to construct elaborate elevators and chutes on barges or derricks, and slung loads with great accuracy into difficult positions. On the days it flew, the Skychief made up to 75 runs from the concrete barge out to the pouring site. (Both, courtesy of the J.E. Greiner Company.)

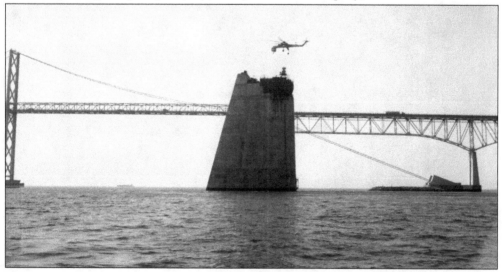

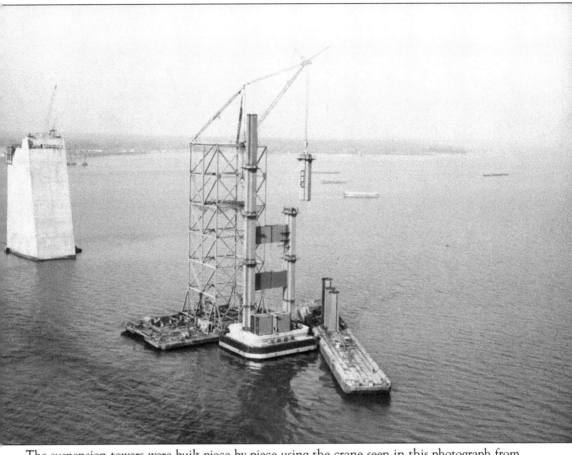

The suspension towers were built piece by piece using the crane seen in this photograph from February 1972. It shows a subtle difference in the towers of the two bridges. The original bridge was built with crisscross bracings in the form of an X, and the new span used the wide lateral bracings seen here. Working from a floating barge, the crane operator latched onto a tower section from the adjacent supply barge, hoisted it up, and guided it into place. The kind of precision operation seen in this photograph—a crane gently pitching and rolling in the bay as it positioned heavy pieces of steel—could only be performed during optimal conditions, and such procedures were frequently delayed. High winds, storms, and heavy ice during the winter of 1969–1970; a labor stoppage; and even a bomb scare conspired to push the bridge's completion date back a year from the mid-1972 goal that was initially set. Construction costs, which rose from the initial $73 million estimate to $110 million by late 1971, would continue to climb. (Courtesy of the J.E. Greiner Company.)

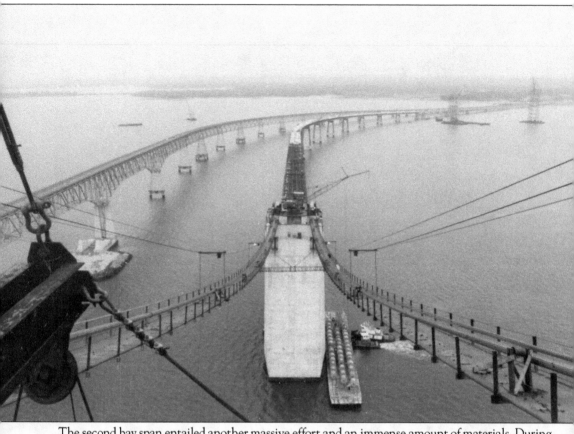

The second bay span entailed another massive effort and an immense amount of materials. During the peak construction period, as many as 900 men worked on the bridge's substructure, which involved pouring 150,000 cubic yards of concrete, 7,000 tons of rebar, and 390,000 linear feet of steel piles. The 3.98-mile-long superstructure was made out of 9,000 tons of reinforced steel and 32,000 tons of structural steel. For the suspension cables that carried the roadway over the shipping channel, some 1,200 tons of steel cable were employed. These were made from many smaller strands of cable that were run from one anchor pier to the other, and then the mass of strands were bundled into a solid cord. In this photograph, taken when work on the suspension cables was about to begin, a barge can be seen pinned against the anchor pier by a tugboat. The barge held dozens of spools ready to be hoisted up by crane. Each spool contained the smaller gauge wire used to make the larger suspension cable. (Courtesy of the J.E. Greiner Company.)

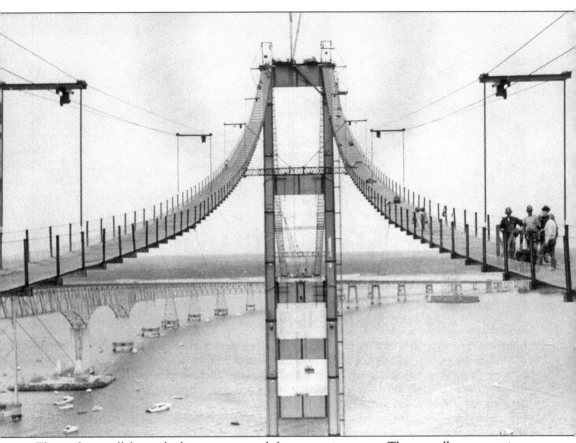

This is the parallel span looking west toward the suspension tower. The catwalks were put into place to allow workers to run the giant cables that held up the suspended roadway. Cable stringers exhausted themselves walking back and forth along these catwalks to guide the many smaller strands of cable from tower to tower, just as workers had done in 1952 while building the suspension cables of the first span. An official pamphlet published by the Maryland State Highway Administration declared that the new bridge would open by the end of 1972, or early 1973, but an unusually wet autumn in 1971 brought delays to the dangerous work of suspension cable stringing. The setbacks caused the Highway Administration Chairman, David H. Fisher, to declare, "I don't see any hope of it being done by the end of next year (1972)." With cable-running operations delayed that fall, the men seen here were forced to work during the winter months when high winds, freezing rain, ice, and snow compounded the danger. (Courtesy of the J.E. Greiner Company.)

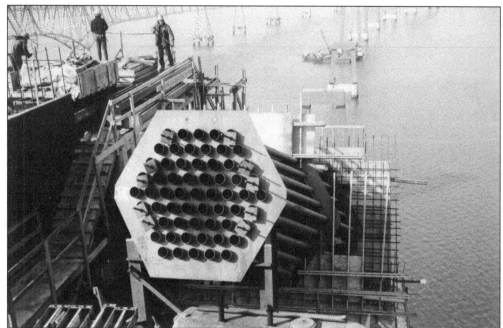

Massive concrete anchor blocks called anchor piers were situated at each end of the suspension section of the bridge. The hulking structures were used to permanently moor the suspension bridge's main cable. The metal tubes seen at the top of this anchor pier were used to encase each smaller bundle of the main cable, providing a solid connection between the wires and the pier. The strands of suspension wire can be thought of as uncooked spaghetti; if a bunch of them are squeezed tightly, it is still possible to slide out some pasta from the middle of the bunch. Similarly with large suspension cables, there is the possibility that the strands may slip, even if they are wrapped tightly. By separating the large cable into many smaller bundles and encasing them in metal tubes, the problem of slippage is solved. (Both, courtesy of the J.E. Greiner Company.)

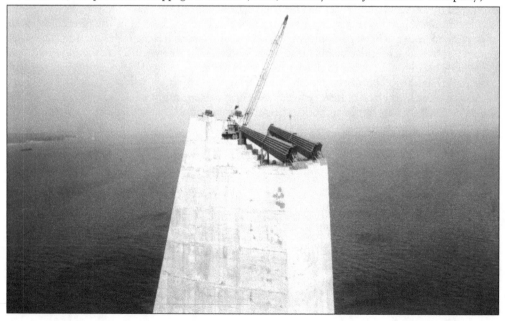

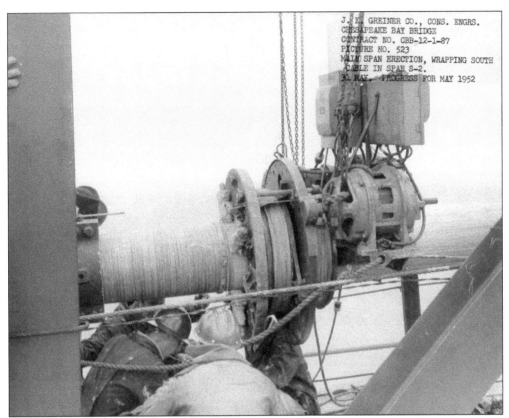

The two suspension cables consisted of thousands of entwined strands of individual wire. After the wires were run, they were wrapped into a tight bundle, a job that workers referred to as "spinning the reels." The machine in this photograph aided that process. It was used to orient the individual wires and compact the main cable to ensure that the individual wires worked as one. (Courtesy of the Maryland Transportation Authority.)

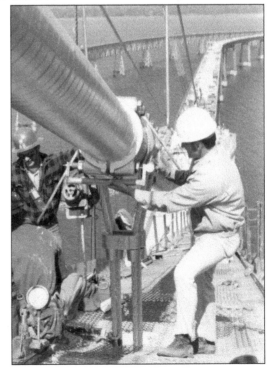

A total of 56 men worked high above the Chesapeake Bay to produce the giant suspension cables. In this photograph, an engineer is verifying that the cable bands are tensioned properly. The bands have to be pulled snug enough to keep the suspender rope in place to support the deck below, but not so tight that they pinch or break wires. (Courtesy of the J.E. Greiner Company.)

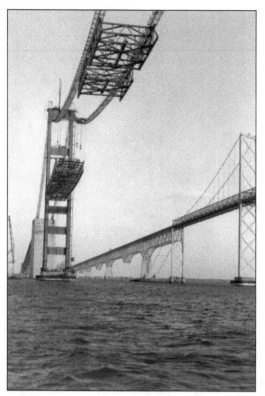

At its highest point, at the top of the suspension tower, the parallel bridge rose to a height of 379 feet above the water. This was slightly taller than the highest point on the original bridge, whose cable towers reached up to 354 feet. The method employed to build the suspended roadway of the second span was similar to that of the first bridge, its neighbor 450 feet to the south. The truss sections for the suspension roadway seen in this photograph were floated in by barge, hoisted, and secured to the hanger cables. (Both, courtesy of the J.E. Greiner Company.)

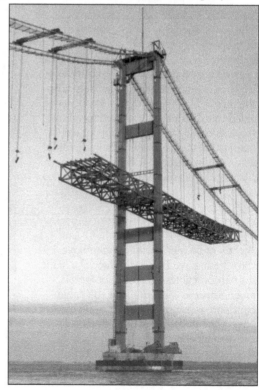

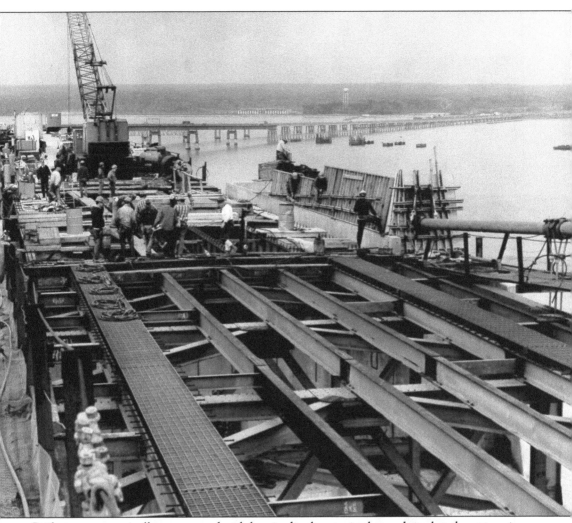

Bridges are not typically constructed with longitudinal grates in the roadway, but the suspension deck of the parallel span was built with slivers of open steel grating, seen being installed here. Because of the width of the bridge and the harmonic resonance caused by air currents, the span needed to have a wind slot to allow air to travel through the deck. The two metal strips of open grid-work on the left and right of the future roadway allowed the bay's hurricane-force gales to pass through the roadway and thereby dissipate such stresses on the bridge. Without this opening, the deck could have galloped, as the Tacoma Narrows Bridge did in 1940. Engineers made advanced calculations and conducted wind tunnel testing to determine the exact placement and opening requirements of the wind grates. Their implementation alleviated any concerns for the bridge's structural integrity. Also visible to the right of the roadway is the completed suspension cable embedded into the west anchor pier. (Courtesy of the Maryland Transportation Authority.)

This photograph from March 1973 shows construction of the Bay Bridge toll collection booths. Here, concrete workers are laying the slab for the underground walkway that would allow workers to reach the tollbooths without having to cross lanes of busy traffic. Workers would walk this tunnel from the Bay Bridge administration building, seen in the background, and climb stairs up to the tollbooths to perform their jobs. (Courtesy of the J.E. Greiner Company.)

This photograph offers another view of the March 1973 installation of the tollbooths. The ramp-like inclines seen here were later replaced by stairs, which were installed to provide easier access for toll collectors to their daily shift. They would walk from the tunnel under the roadway up into the toll collection booths. (Courtesy of the J.E. Greiner Company.)

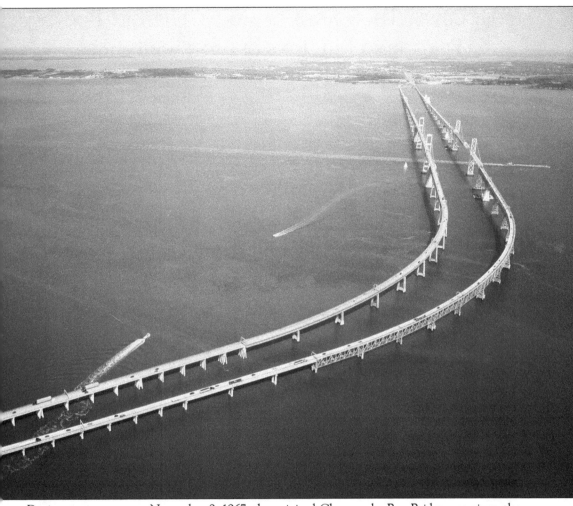

During a ceremony on November 9, 1967, the original Chesapeake Bay Bridge was given the official name it now bears, the William Preston Lane Jr. Memorial Bridge, to honor the governor whose efforts helped bring the bridge into being. The second span opened to traffic on June 28, 1973, and joined the first span as the two longest water crossings in Maryland. The first span cost $45 million to build, and the second span was double its initial estimate, with a final tally of $148 million. Today, the two highways that comprise the Chesapeake Bay Bridge are among the world's longest over-water structures, and together have enabled the two halves of Maryland to become unified. The influx of people using the bridge has enabled both sides to grow. Many people believe that the existing transportation facilities for connecting the Eastern and Western Shores have reached their limit, and an additional bridge will soon be required to alleviate congestion. The debate for a third span somewhere over the Chesapeake Bay to increase cross-bay capacity may be lurking just around the corner. (Courtesy of the Library of Congress.)

DISCOVER THOUSANDS OF LOCAL HISTORY BOOKS
FEATURING MILLIONS OF VINTAGE IMAGES

Arcadia Publishing, the leading local history publisher in the United States, is committed to making history accessible and meaningful through publishing books that celebrate and preserve the heritage of America's people and places.

Find more books like this at
www.arcadiapublishing.com

Search for your hometown history, your old stomping grounds, and even your favorite sports team.

Consistent with our mission to preserve history on a local level, this book was printed in South Carolina on American-made paper and manufactured entirely in the United States. Products carrying the accredited Forest Stewardship Council (FSC) label are printed on 100 percent FSC-certified paper.

MADE IN THE

USA

Printed in the USA
CPSIA information can be obtained
at www.ICGtesting.com
LVHW080735021023
759825LV00010B/201

.